PENGUIN BOOKS

PARIS VERSUS NEW YORK

THE COMPLETE SERIES OF TWO CITIES

VAHRAM MURATYAN is a graphic artist. His work mixes commissioned work in print for high-profile clients such as Prada, colette, the City of Paris, Le Monde — and more personal projects. In 2010, during a long stay in New York City, Vahram launched his first blog ***Paris versus New York, a tally of two cities.*** Within a year, the site is viewed more than four million times, the works are shown at colette in Paris and The Standard in Manhattan, and in early 2012, the first version of the book *Paris versus New York* is released in the USA. Vahram lives now between the City of Light and the Big Apple while being at work on his next journey. **www.vahrammuratyan.com**

VAHRAM MURATYAN

Paris versus New York

THE COMPLETE SERIES OF TWO CITIES

PENGUIN BOOKS

PENGUIN BOOKS
Published by the Penguin Group
Penguin Group (USA) Inc., 375 Hudson Street, New York, New York 10014, U.S.A.
Penguin Group (Canada), 90 Eglinton Avenue East, Suite 700, Toronto, Ontario, Canada M4P 2Y3
 (a division of Pearson Penguin Canada Inc.)
Penguin Books Ltd, 80 Strand, London WC2R 0RL, England
Penguin Ireland, 25 St. Stephen's Green, Dublin 2, Ireland
 (a division of Penguin Books Ltd)
Penguin Group (Australia), 707 Collins Street, Melbourne, Victoria 3008
 (a division of Pearson Australia Group Pty Ltd)
Penguin Books India Pvt Ltd, 11 Community Centre, Panchsheel Park, New Delhi – 110 017, India
Penguin Group (NZ), 67 Apollo Drive, Rosedale, Auckland 0632, New Zealand
 (a division of Pearson New Zealand Ltd)
Penguin Books, Rosebank Office Park, 181 Jan Smuts Avenue, Parktown North 2193, South Africa
Penguin China, B7 Jaiming Center, 27 East Third Ring Road North, Chaoyang District, Beijing 100020, China

Penguin Books Ltd, Registered Offices:
80 Strand, London WC2R 0RL, England

First published in Penguin Books 2012
This expanded edition published 2012

10 9 8 7 6 5 4 3 2 1

Copyright © Vahram Muratyan, 2011, 2012
All rights reserved

Originally published in France as *Paris vs New York* by Editions 10/18, an imprint of Univers Poche, Paris, 2011.

Some of the contents of this book first appeared on the author's blog, *Paris versus New York, a tally of two cities*, « les galeries » (214-215), « la folie » (224-225) were first published in France in *M le magazine du Monde*.

THE LIBRARY OF CONGRESS HAS CATALOGED THE REGULAR HARDCOVER EDITION AS FOLLOWS:
Muratyan, Vahram.
[Paris vs New York]
Paris versus New York : a tally of two cities / Vahram Muratyan.
 p. cm.
Originally published: Paris vs New York. Paris : Editions 10/18, c2011.
ISBN 978-0-14-312025-4 (hc.)
ISBN 978-0-14-312383-5 (expanded hc.)
1. Muratyan, Vahram—Themes, motives. 2. Paris (France)—In art. 3. New York (N.Y.)—In art. I. Title.
NC999.6.F8M87 2012
741.6092—dc23 2011044058

Printed in France by Pollina
Designed by Vahram Muratyan

the story

After a long journey across continents and centuries — from East to West, from the lands of Anatolia by way of Istanbul, Gallipoli, Thessaloníki, and Venice — my family staked their claim in **Paris.** I was born in Paris, and yet her culture, her worldliness, her beauty continue to take me by surprise. Growing up in such a seductive place is its own kind of magic. Paris is known for her charming streets, her infinite possibilities, her mystery; I love her for her unpredictable moods, her whimsical nature, the whirlpools that churn beneath her surface calm. She embodies the essence of her people, and I love her despite all her complications, big and small. On a bicycle, by subway, or on foot, I plunge down her bustling, narrow streets, I cross her from *rive* to *arrondissement*, ready to discover what she has in store for me: a conversation on a café terrace, a subtitled Korean movie, a quaint covered market in an unknown neighborhood, a run along the Seine, a jaunt around the city at the first signs of spring. The whole world dreams of paying her a visit; I, in turn, dream of seeing the world. As a child, atlases made me want to zoom out, to encounter faraway places, to imagine alternatives to the life I led, to travel even farther west and move beyond the city my family claimed as home.

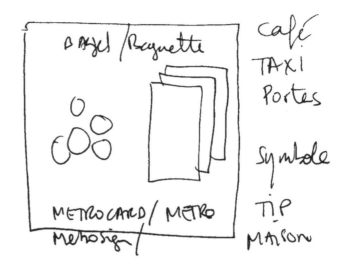

café
TAXI
Portes

Symbole

TIP
MAISON

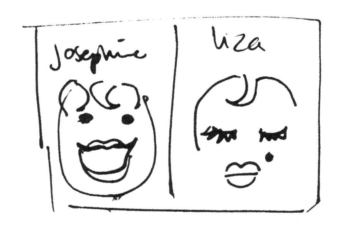

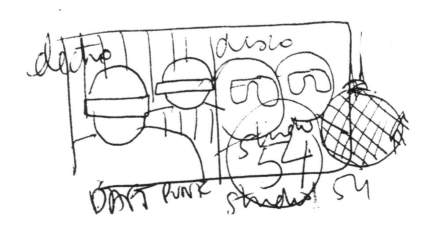

Hello, New York. The first time she and I meet, I am five and I am dwarfed by the Big Apple. Later, as a teenager, I experience an exhilarating feeling of sensory overload before the never-ending skyline, the limitless variety of perspectives: Art Deco and Neo-Gothic buildings rising up side by side; the giant shadows of skyscrapers; the bold mix of culinary traditions; the wild enthusiasm of her inhabitants. Like a siren, New York calls to me. In 2010, I decide to live there for a few months to discover whether I can make her mine.

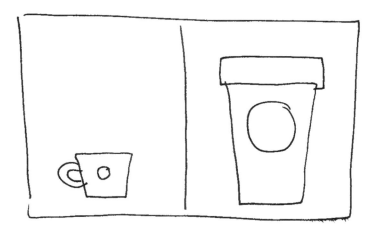

I sit in the New York subway, the train hurtling downtown as a tunnel swallows up the sound of screeching wheels, the air conditioning set at a chilly sixty degrees. I watch the people around me, sketching some poses in my notebook: a worker in coveralls snoozes in his seat; an office girl chats with her colleague, a coffee in hand. Ideas come, go, and come again. I write some down, forget others. I draw an espresso cup facing a giant coffee to go; a bent-over old lady facing a grandmother in jogging pants... A series of pairs take shape on the page, comparisons that I instantly want to share with family and friends, day by day. And so my **Paris versus New York** blog comes into being. Almost overnight, my work becomes a sort of tapestry, weaving connections between travelers, dreamers, and romantics alike. The universal appeal these two cultural capitals have takes me by surprise, and soon more paired images take shape and the blog turns into an experiment for the book you now hold in your hands.

This friendly visual match is dedicated to all lovers of Paris, of New York, and to those who are torn between the two.

vahram muratyan
July 23, 2011

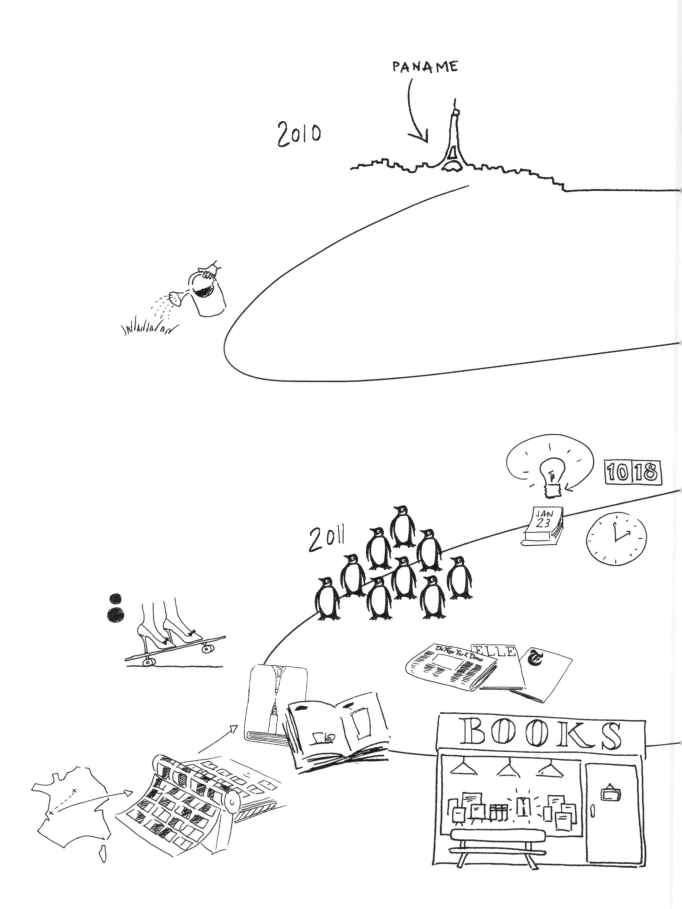

the journey

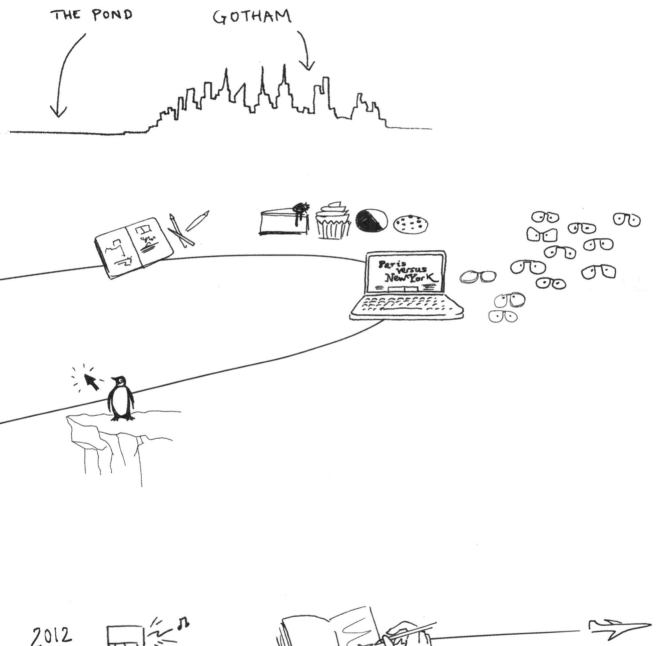

THE POND

GOTHAM

Paris versus New York

2012

ville lumière

big apple

CDG

JFK

indications

libre — occupé — fin de service

lights

free — taken — off duty

vous êtes ici

you are here

pierre de taille

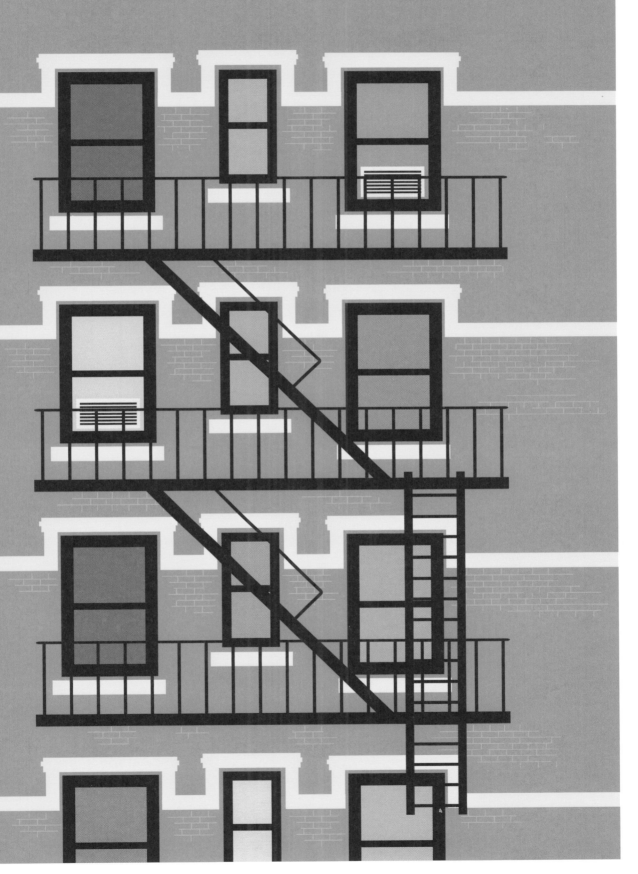

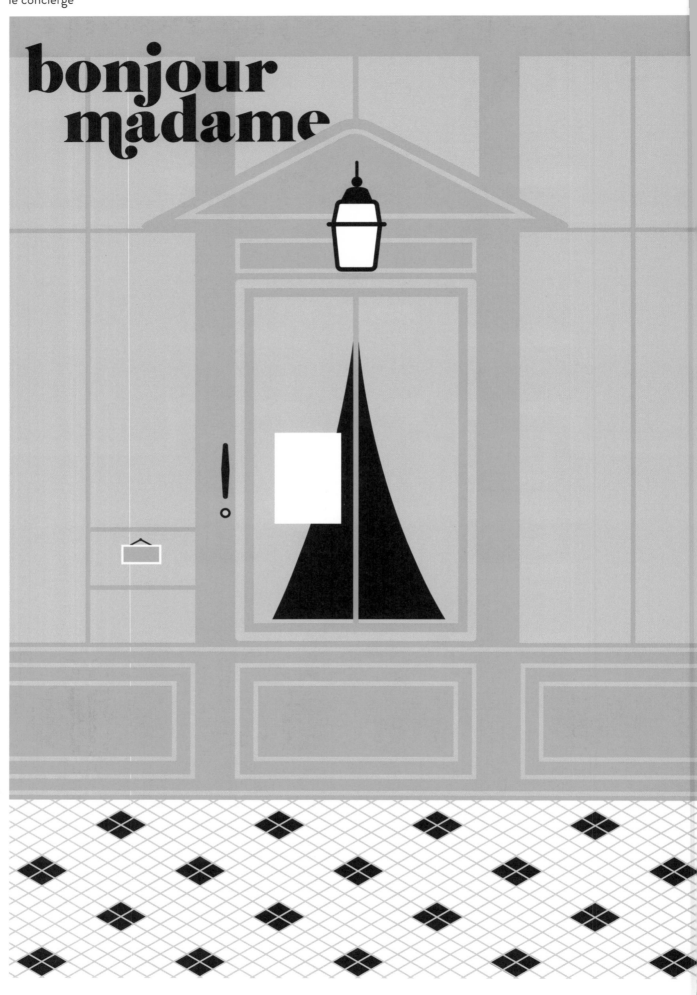

welcome back

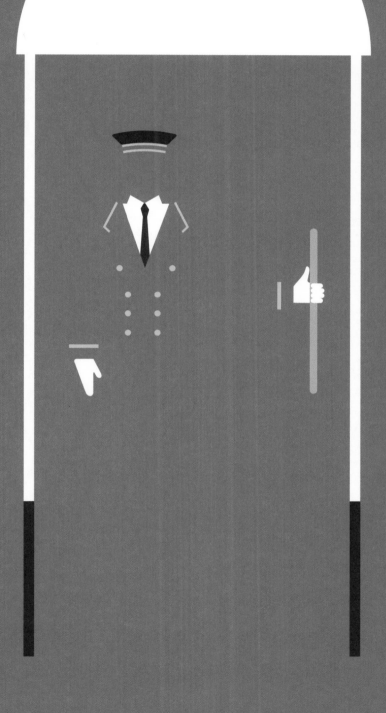

cage

going up

appart

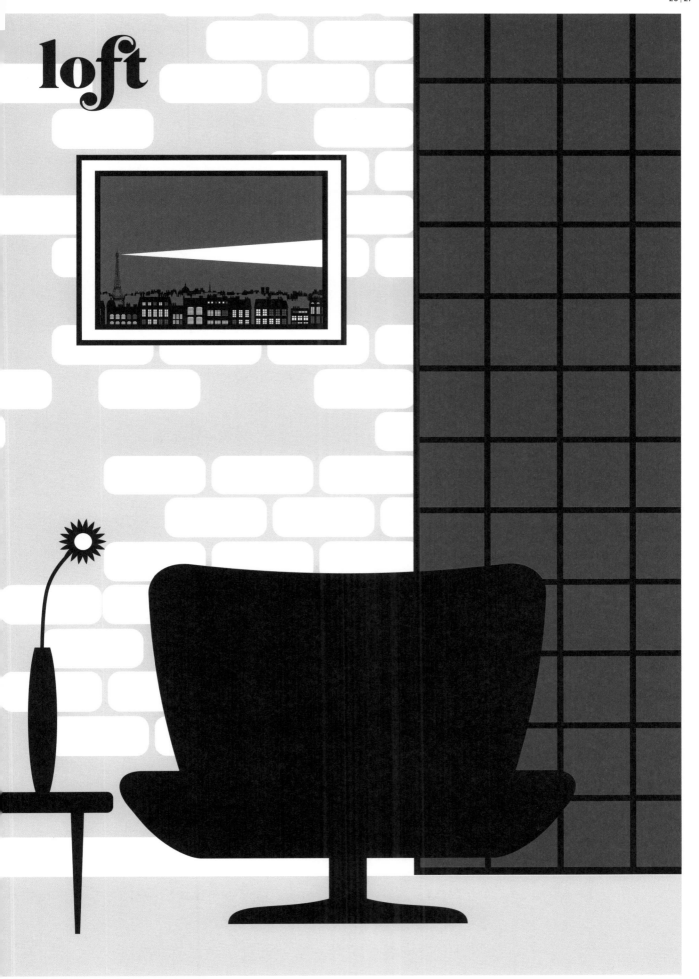

loft

orientation

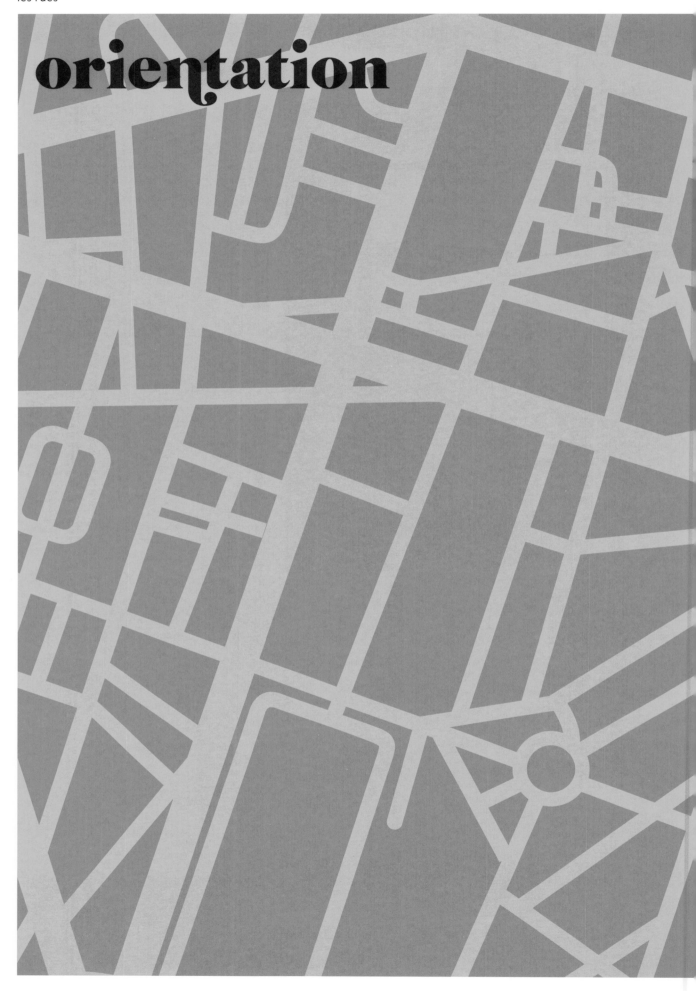

location

rive droite
rive gauche

17

16

15

13

8-14

6

3-11

4

1 2

la seine

2

1

4

3

6

3bis

8

8bis

5

10

7

west side
east side

5th avenue

W24 W10

W47 W21

E20

E11 E31

NON,
j'aime rien je suis parisien

never take no for an answer

explication

direction

attendez

don't walk

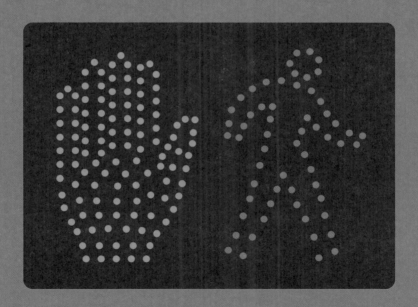

traversez

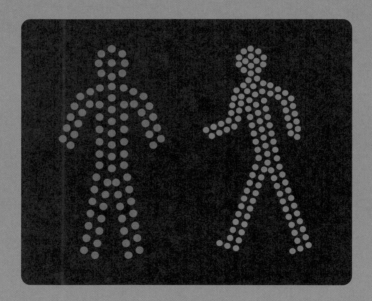

walk

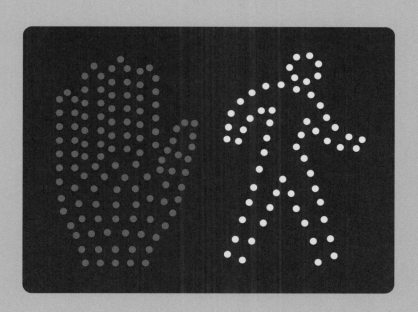

c'est magnifique

look!

chef d'œuvre

st-jacques
4ᵉ arr. (1523)

bête noire

montparnasse
15ᵉ arr. (1973)

master class

flatiron
23rd st. (1902)

skyline spoiler

verizon
financial district (1975)

pyramide

entrée des artistes

entrance for the geeks

mona lisa

au musée du louvre

les demoiselles

at the moma

quasimodo

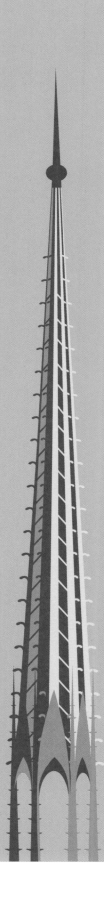

king kong

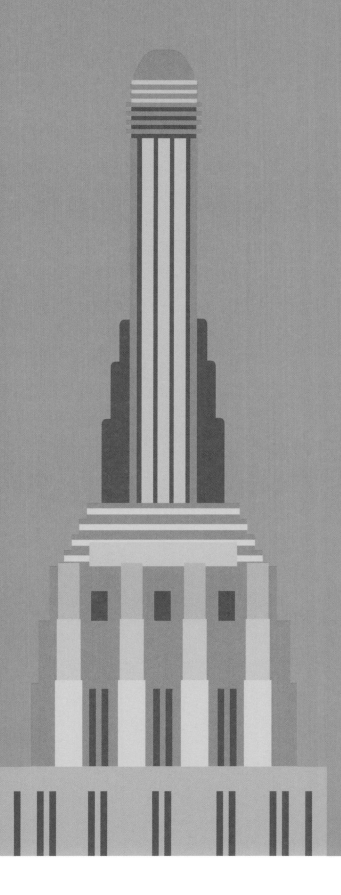

quai branly

natural history

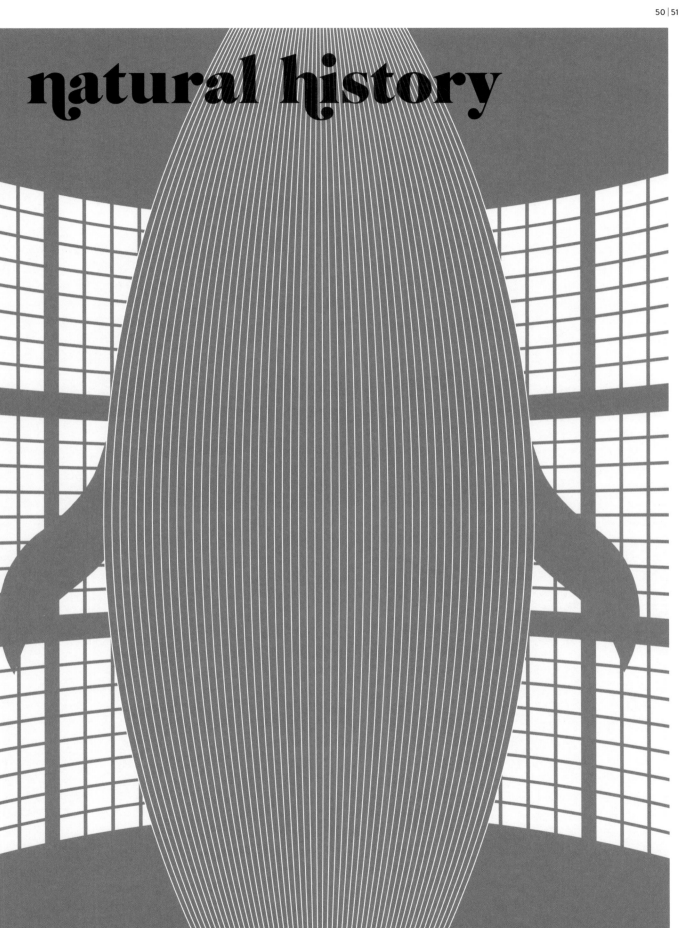

disneyland

times square

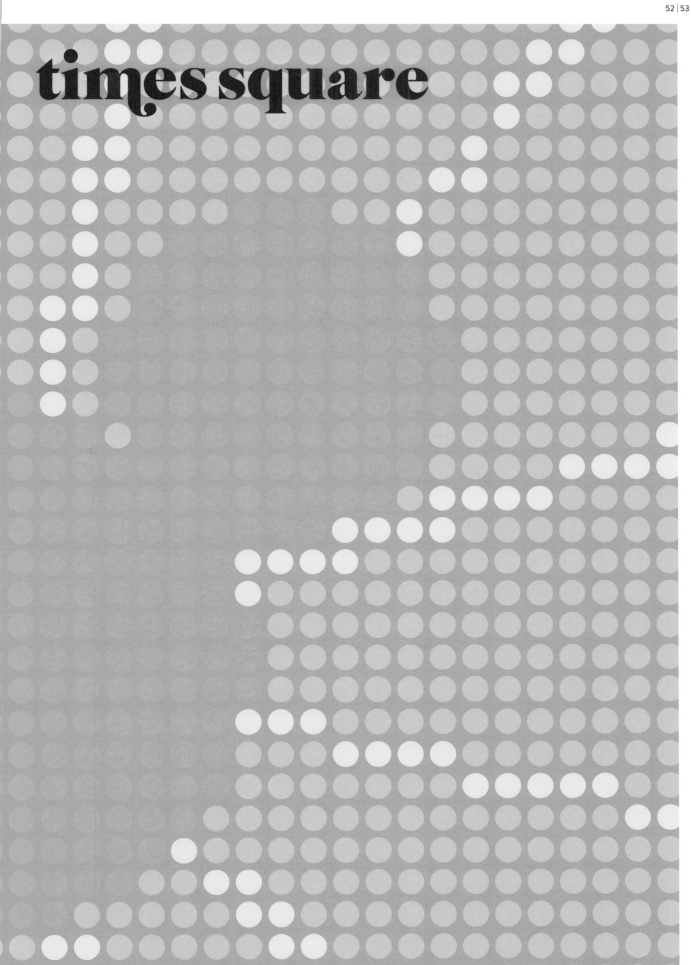

croque-monsieur

créé en 1910 boulevard des capucines

hot dog

created in 1870 in coney island

pepé le pew

à la poursuite du grand amour dans le quartier latin

squirrel

on the hunt for hot dog buns in central park

jardin

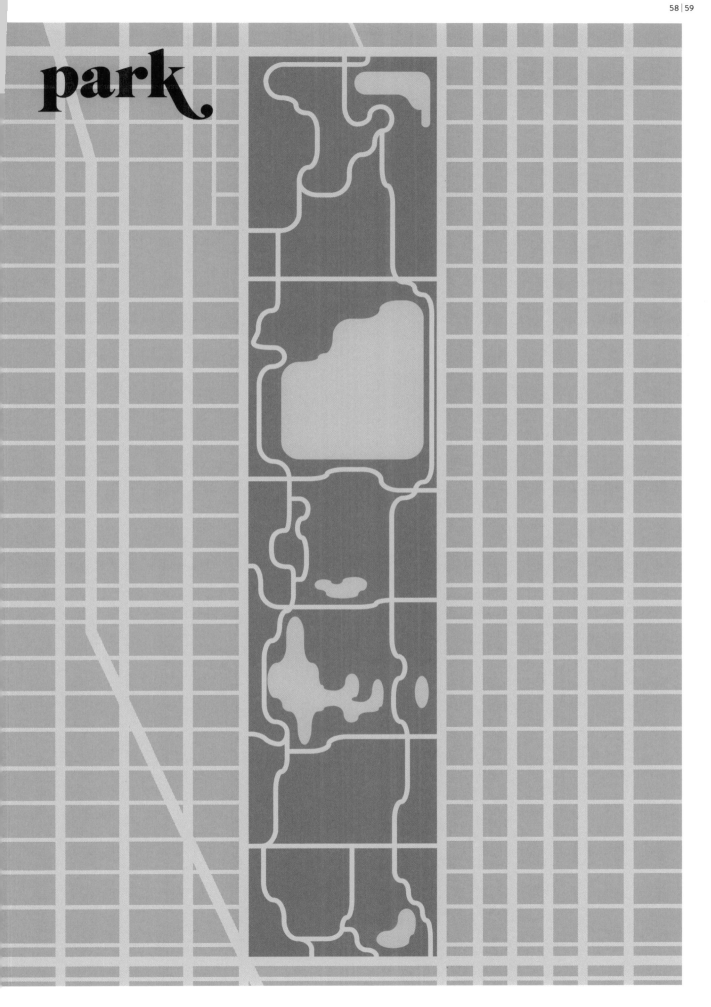

park.

bastille

bethesda

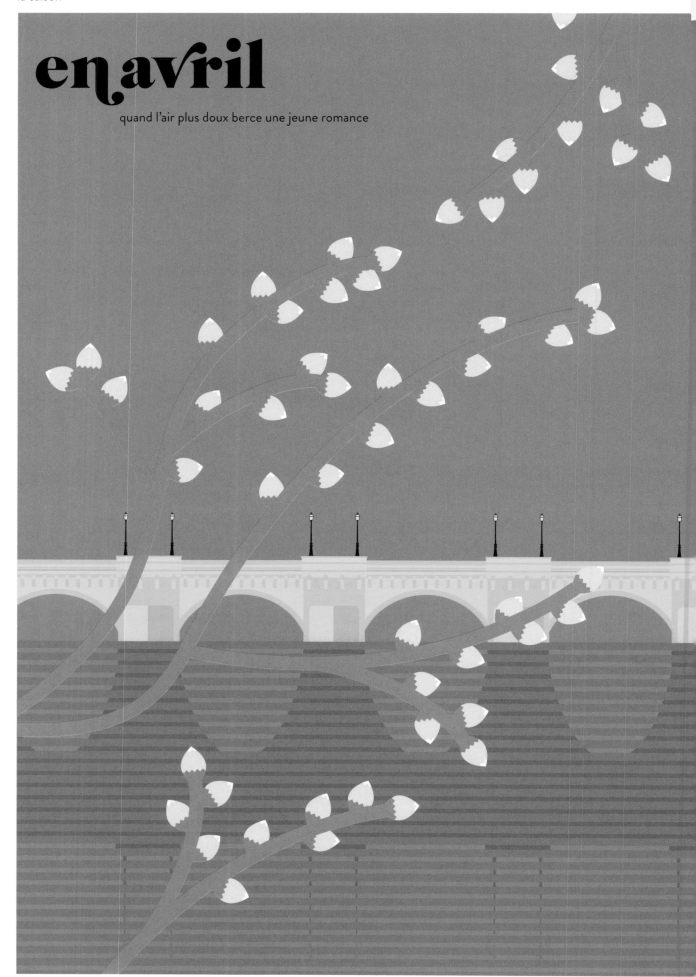

en avril

quand l'air plus doux berce une jeune romance

in september

experiencing indian summer

novembre

november

hiver

cinq centimètres et c'est la panique

winter

alternate side parking has been suspended

pont des arts

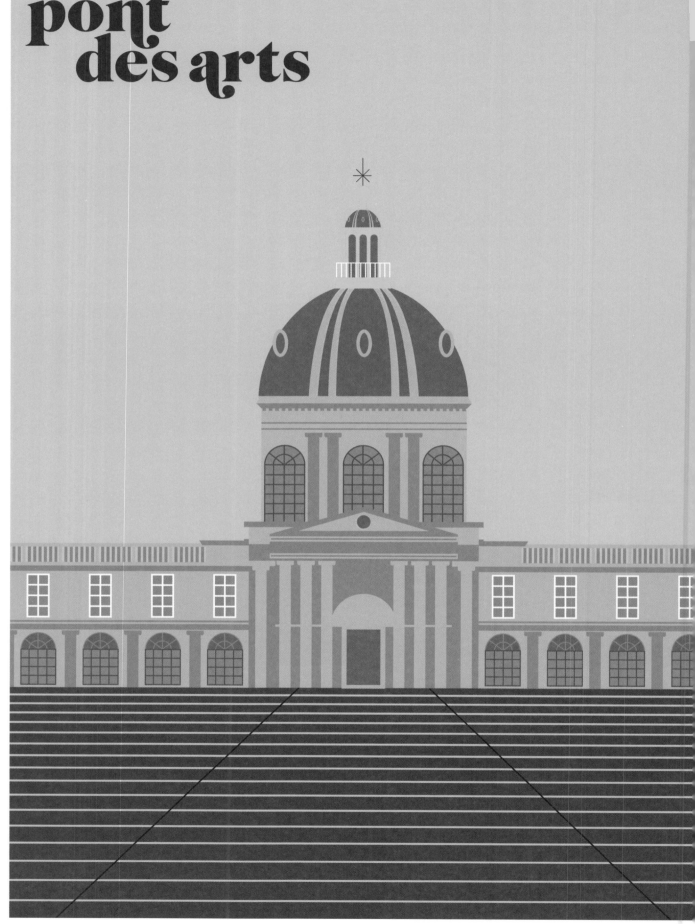

brooklyn bridge

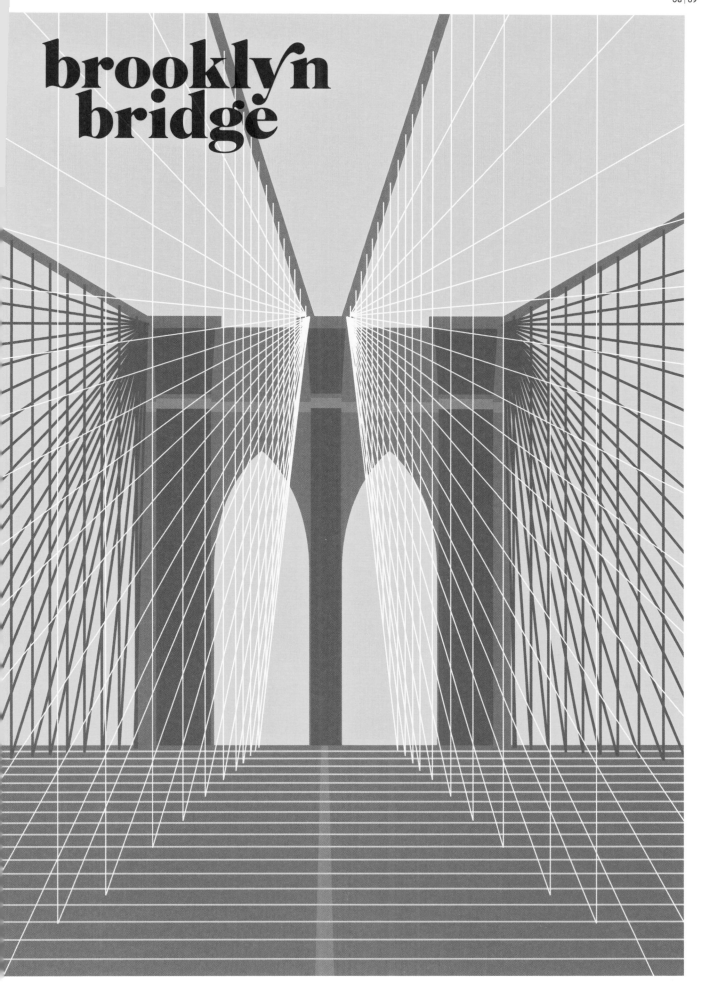

place des vosges

brooklyn heights

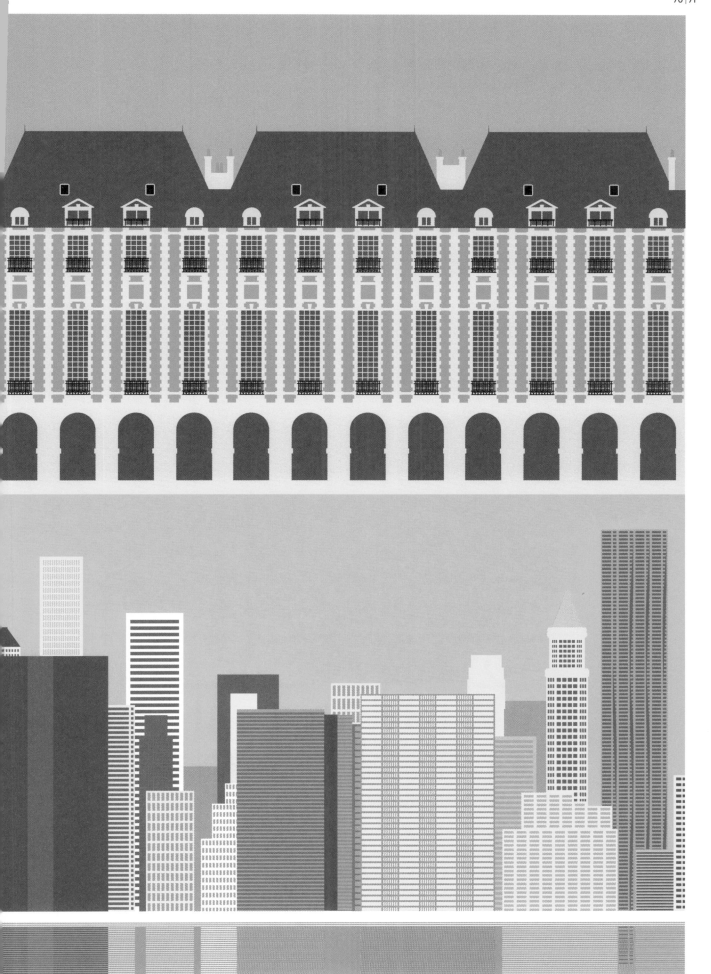

pâtisserie

pastrami

bouquins

newsies

ventilo

freshair

double file

high rise

savoir-faire

dans les 9e – 11e – 15e – 20e arrondissements

bringing up

in park slope – upper west side – tribeca

vieille dame

au parc monceau

forever young

in central park

debussy

gershwin

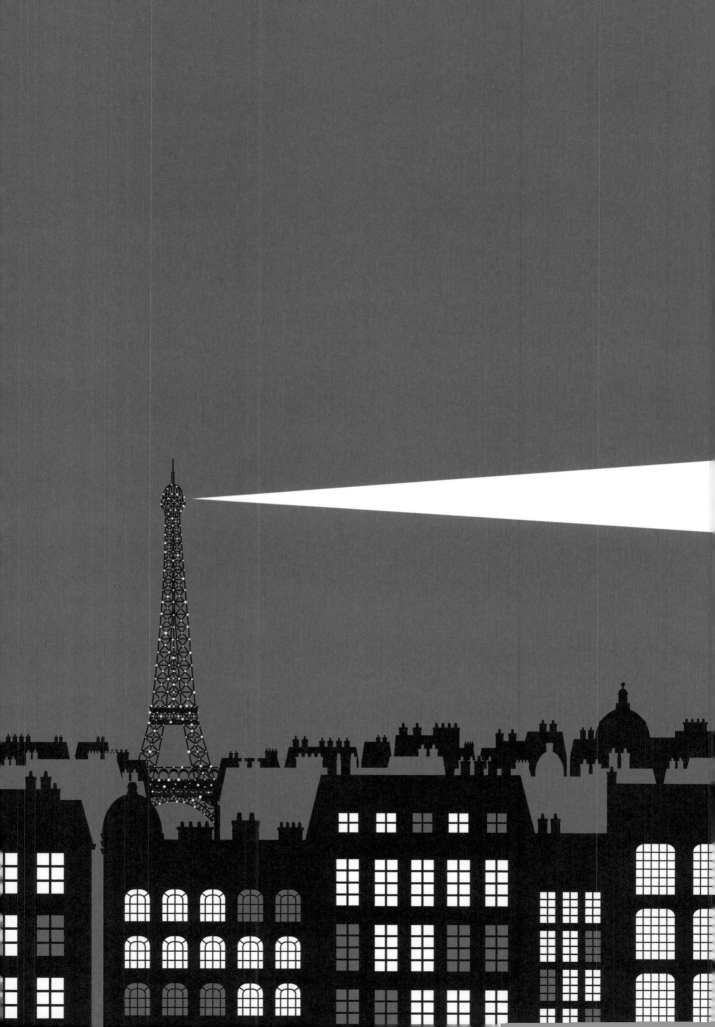

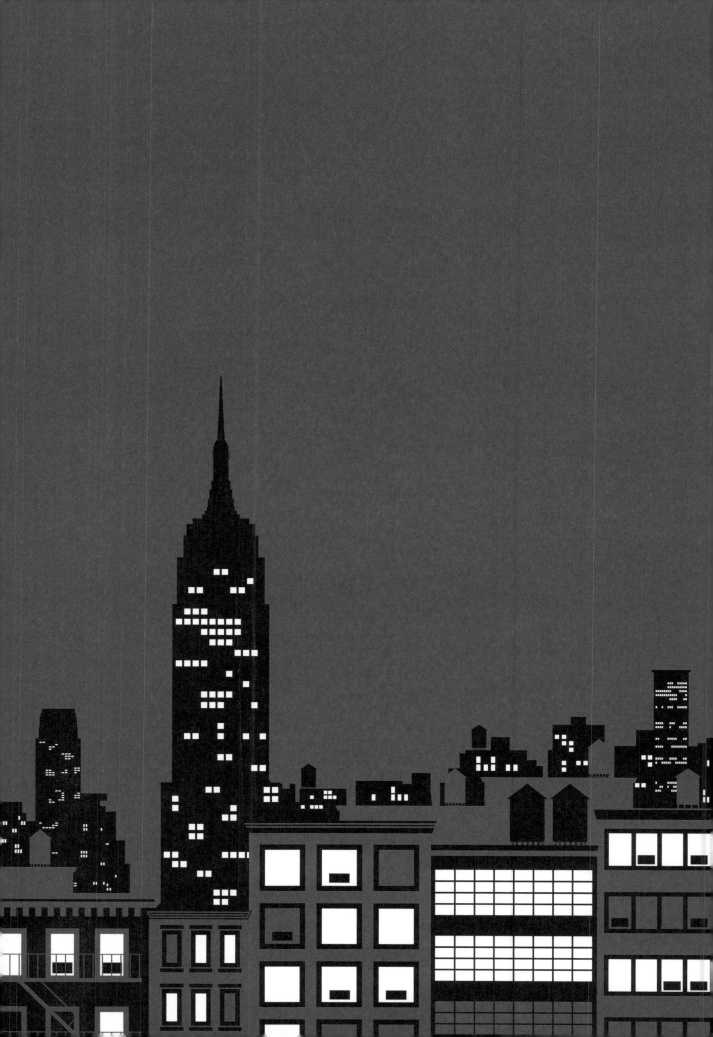

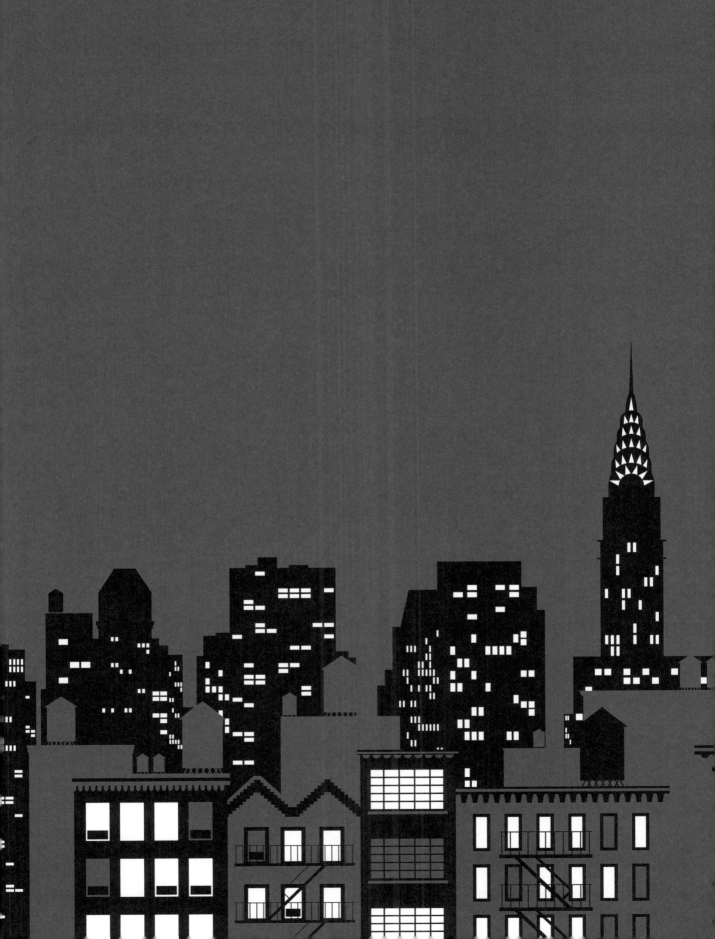

la vie bohème

au bord de l'île saint-louis

american dream

through ellis island

marie-antoinette

madonna

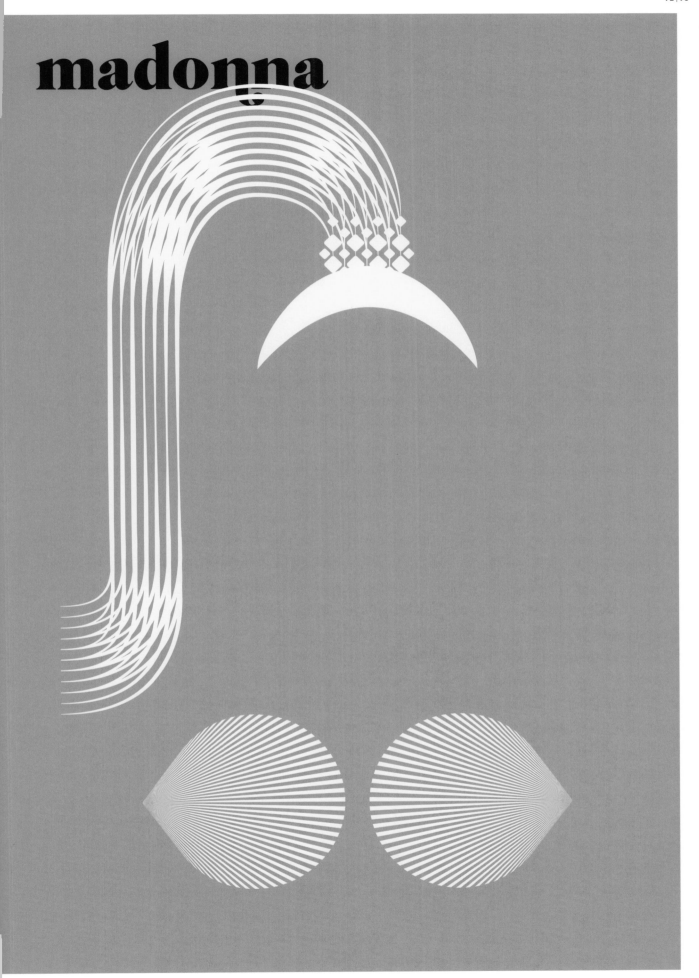

joséphine

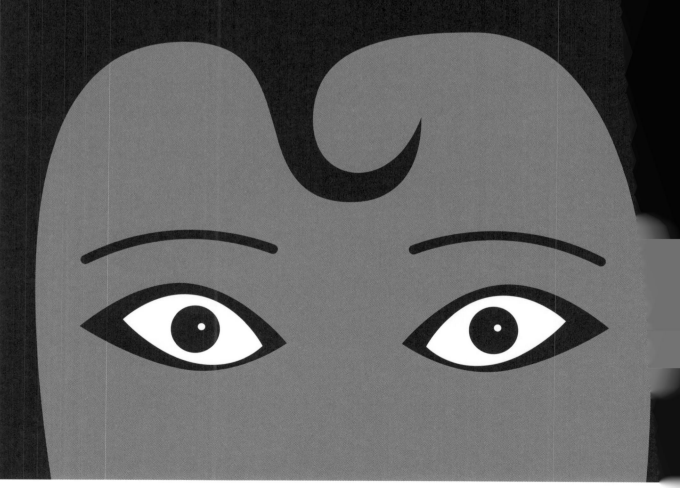

liza.

cancan

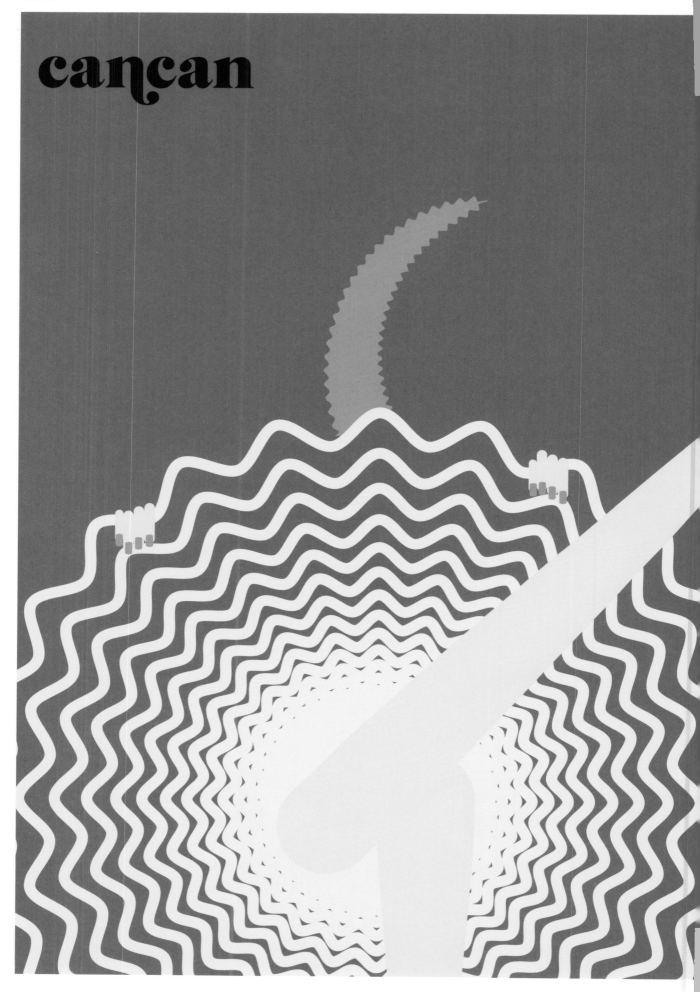

gaga

grand rex

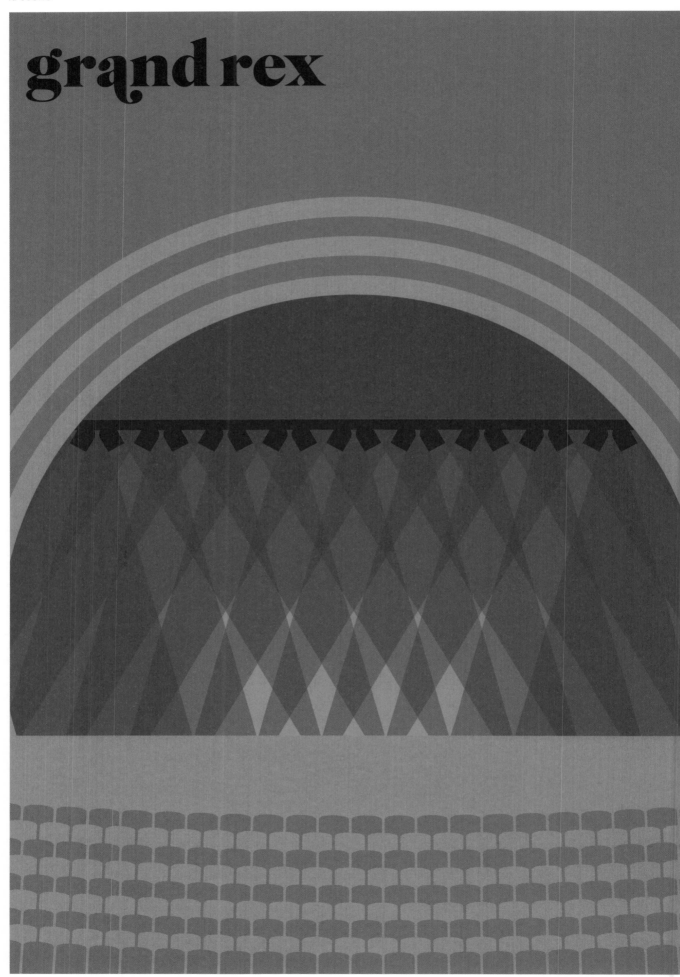

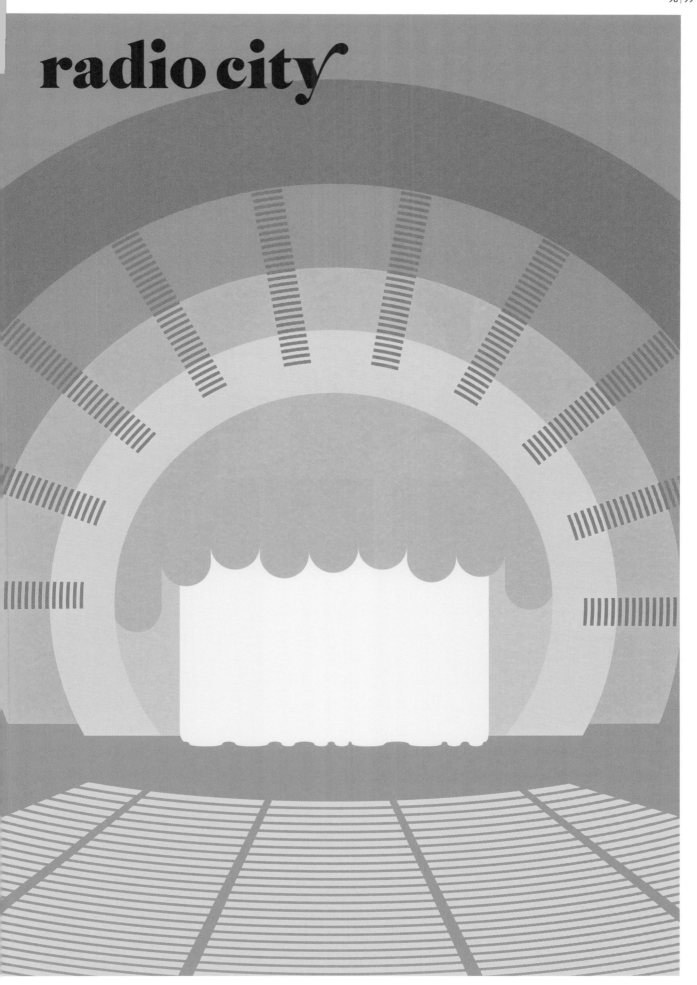

promotion

construction

aznavour

se voyait déjà en haut de l'affiche

sinatra

if you make it here, you'll make it anywhere

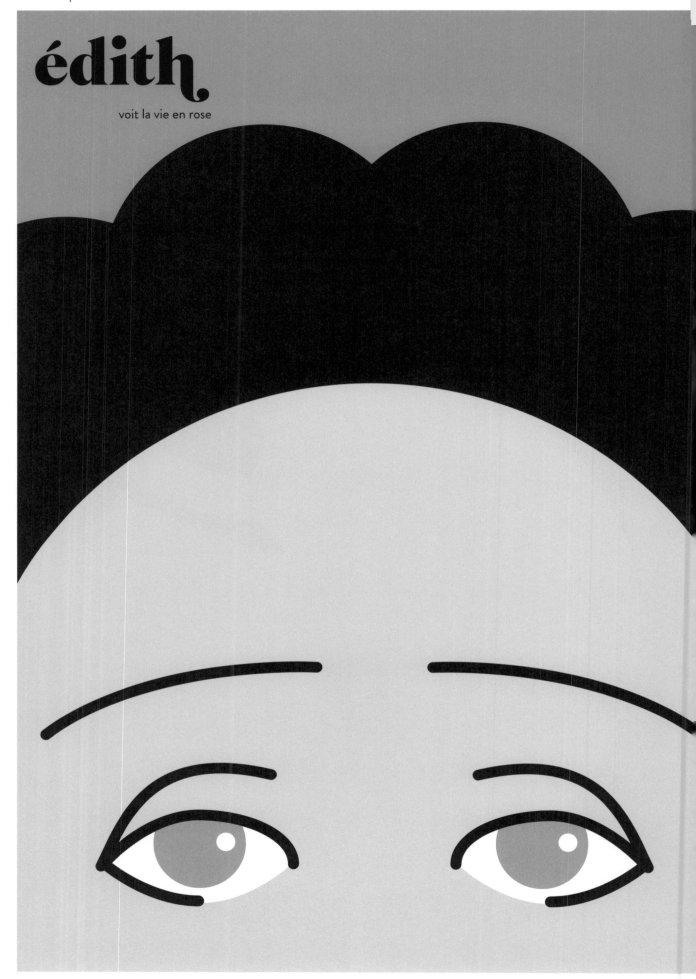

édith.

voit la vie en rose

barbra

is a woman in love

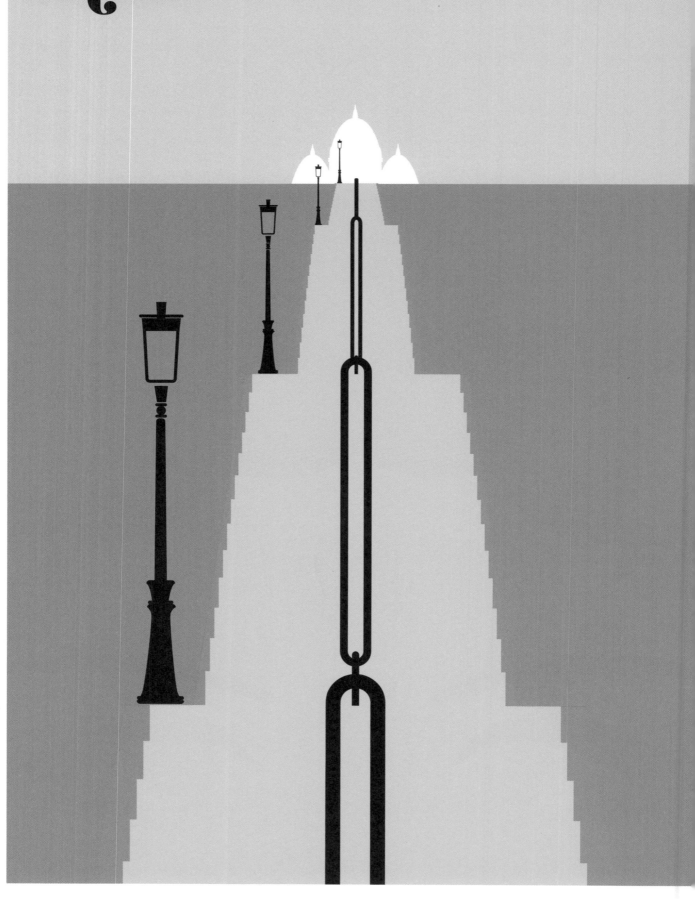

butte

brownstone

funiculaire

pour monter au sacré-cœur

roosevelt tram

to cross the east river

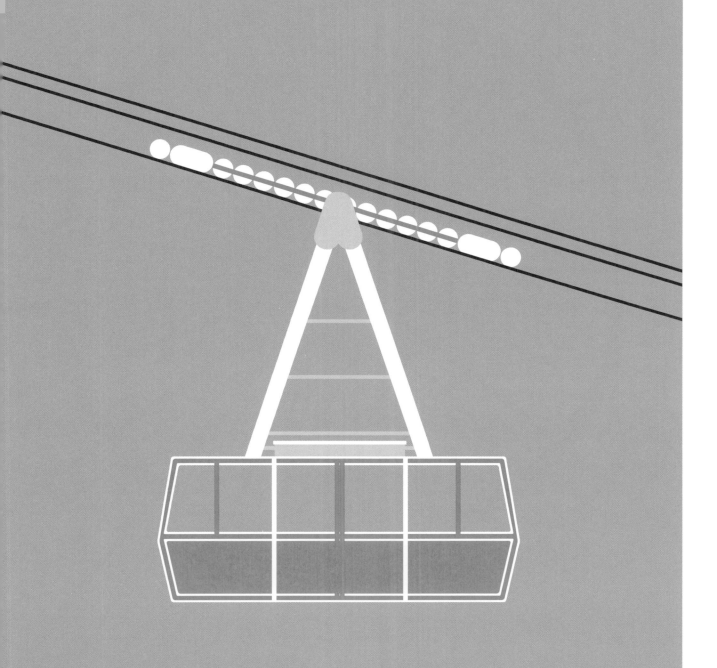

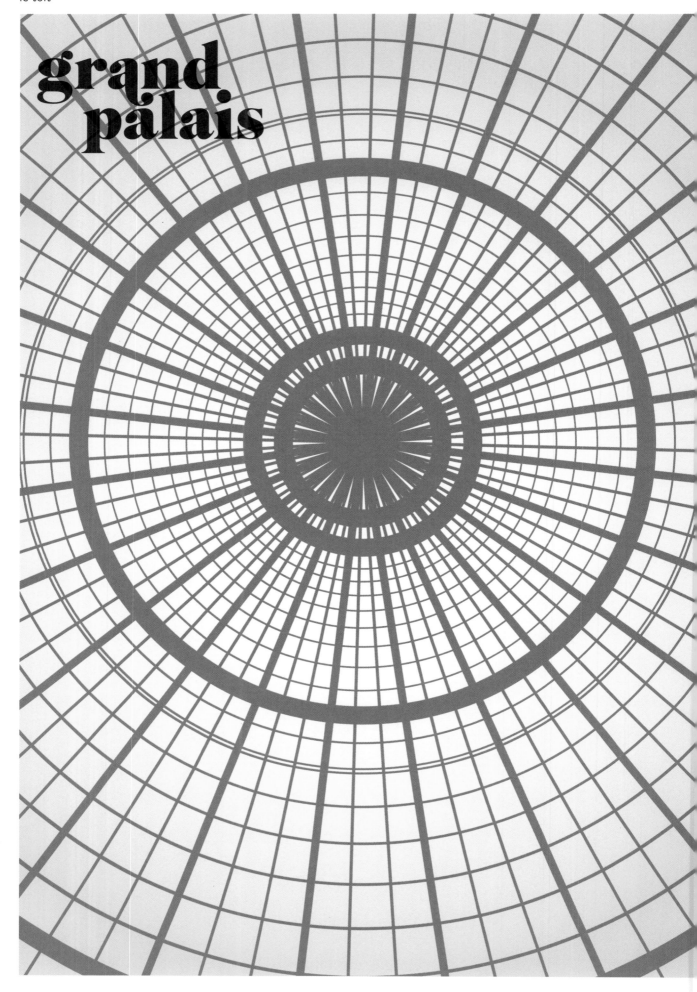

grand palais

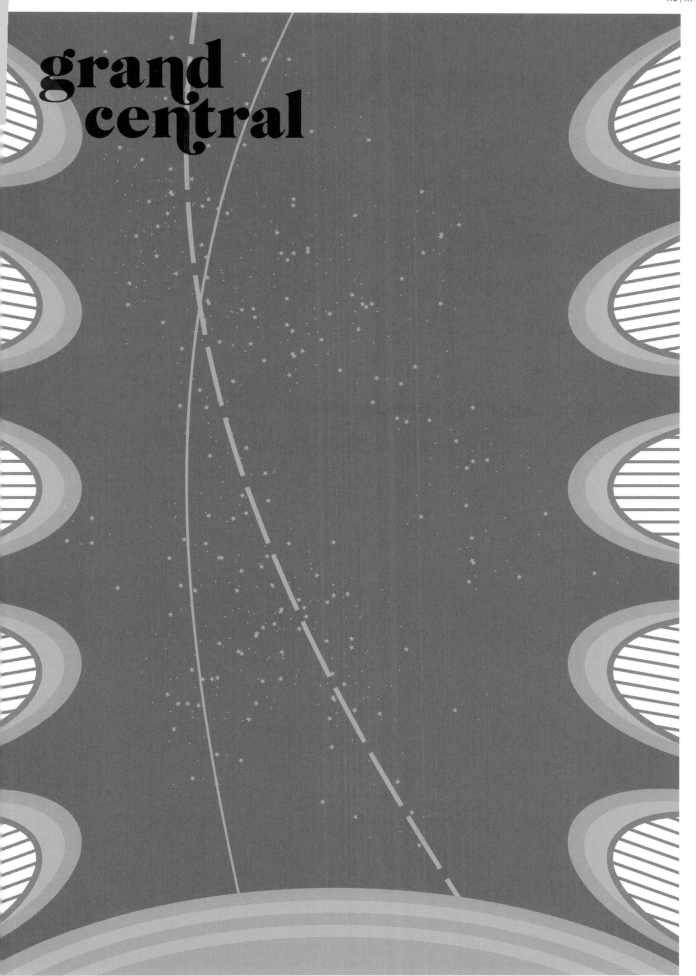

grand central

devantures

block

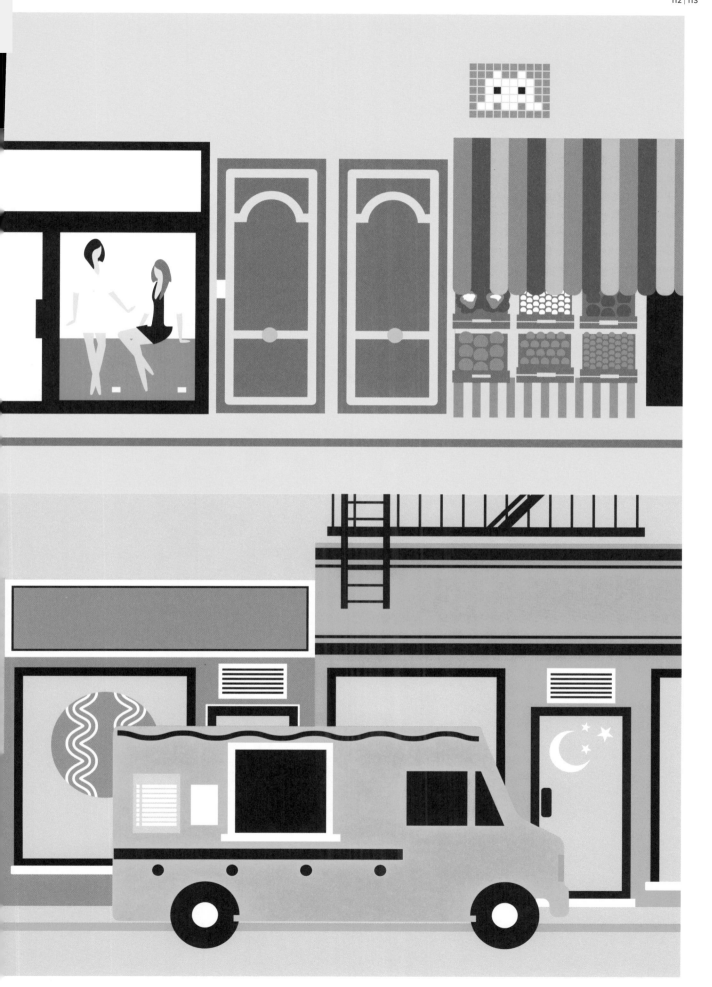

trace

tag

ballet

basket

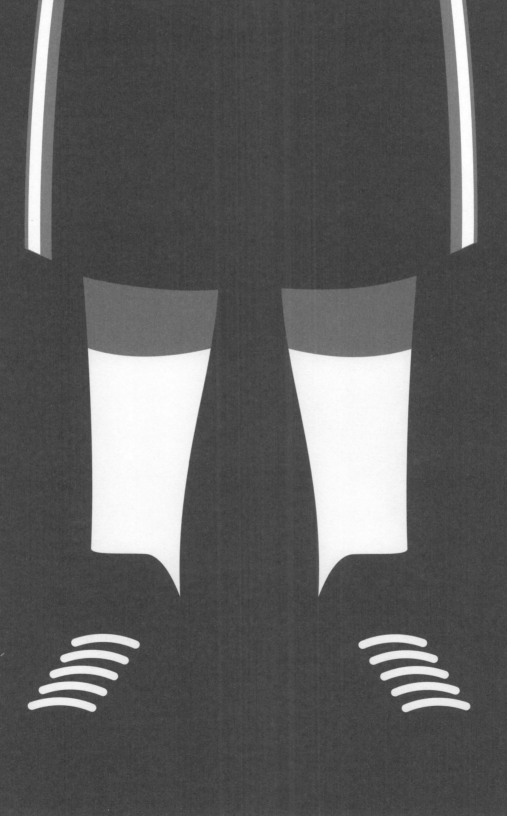

le marais

chelsea

burger

at madison square park

NEW YORK STATE

Inwood

Murray Hill

Financial District

Washington Heights

Grand Central

Wall Street

Midtown West

Flatiron

Washington Square ■

Rockefeller Center

Columbus Circle

Times Square

Upper West Side

Guggenheim ■

Hudson River

CENTRAL PARK

PS1 ■

Upper East Side

Manhattanville

Empire State Building ■

Yorkville

Sutton

Turtle Bay

Tudor City

Hamilton Heights

Flushing Meadows ■

Columbia University

Giants Stadium ■

Battery Park City

Lenox Hill Hospital ■

Kips Bay

Penn Station ■

Bedford Stuyvesant

NEW JERSEY

■ Yankee
Stadium

BRONX

✈ JFK `

Jamaica

Harlem

East Harlem

Long Island City

Morningside
Heights

Williamsburg

QUEENS

Gramercy

Koreatown

Diamond
District

Alphabet City

Dumbo

Vinegar
Hill

Astoria

Theatre
District

MANHATTAN

Lincoln
Square

Lower
East Side

NoMad

Port Authority
Bus Terminal ■

Bushwick

Union Square

NoHo

Hell's
Kitchen

Boerum
Hill

Greenpoint

The Met ■

West Village

BROOKLYN

MoMA ■

NoLita

Roosevelt
Island

City
Hall ■

Meatpacking

Fort Greene

Ellis
Island

SoHo

Chelsea

TriBeCa

High
Line ■

East Village

Brooklyn
Heights

Greenwich
Village

Bowery

Cobble Hill

NYU

Carroll
Gardens

Prospect
Heights

Museum of ■
Natural History

East River

■

Little Brazil

New York
Public Library ■

Park Slope

PROSPECT
PARK

Little Italy

Red Hook

South Slope

Chinatown

Windsor Terrace

Clinton Hill

STATEN
ISLAND

✈ LA GUARDIA

◄

la goutte d'or
le marais
quartier de l'horloge
canal st-martin

hell's kitchen
meatpacking
alphabet city
canal street

VAL D'OISE

YVELINES

La Seine Rive Gauche

Île St-Louis

15e Barbès

Commerce

Opéra ■
Garnier

17e BOIS DE
BOULOGNE

Rochechouart

9e Madeleine

Champs-Élysées

Montaigne

Louis Blanc

■ Beaubourg

St-Lazare

Grands Boulevards

8e

Temple Bonne
Nouvelle Vaugirard

Gaîté Denfer

■ Gare du Nord

Montparnasse

3e République Bercy

Tour Eiffel ■ Magenta

Enfants
Rouges **PARIS**

Le Marais

Coulée
Verte **4e**

BNF Folie-Méricourt

Les Halles Arc ■
de Triomphe Gaillon

St-Paul La Sorbonne **10e**

5e St-Germain-des-Prés

Sentier **6e** Odéon Bastille

Oberkampf

Quartier chinois

1er **13e** **11e**

Hôtel ■
de Ville Belleville

Bourse Cour
St-Emilion Canal de l'Ourcq

2e

La Défense

Canal St-Martin Ménilmontant

Butte
aux-Cailles Beaugrenelle

Batignolles Buttes-Chaumont

Goutte d'Or

La Tour-
Maubourg

Le Louvre

Invalides 7e

6e Passy

Auteuil

St-Honoré

Île de la Cité

Porte
d'Auteuil

Roland-Garros

Alésia 14e

La Seine Rive Droite

Daguerre

Plaisance

Bassin de l'Arsenal

Porte
d'Orléans

HAUTS-
DE-SEINE

La Villette

Stalingrad

20e

Picpus

Porte
des Lilas

Faidherbe

Jules
Joffrin

ROISSY CDG

Montmartre

18e

Jourdain

Popincourt

Bel-Air

Marx Dormoy

Daumesnil

19e

Nation

Porte
de Bercy

12e

Montgallet

Porte
de Clignancourt

Javel

Colonel
Fabien

Puces
de St-Ouen

ESSONNE

ORLY

la crotte

porte-bonheur

sh*t !

sèche-linge

pas de culottes aux fenêtres

self-service

no machine in low-rise apartments

bateau-mouche

mise en seine parisienne pour touristes de tout bord

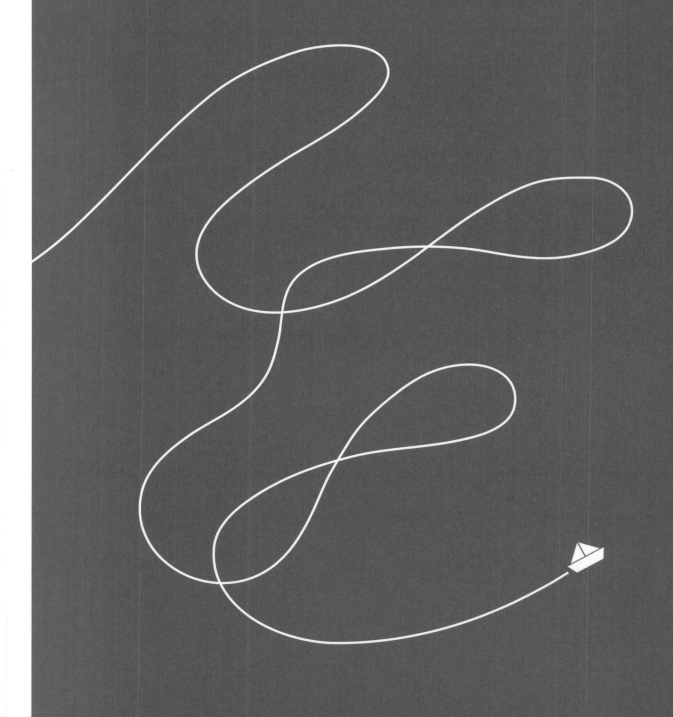

circle line

a full island three-hour cruise that keeps tourists at sea

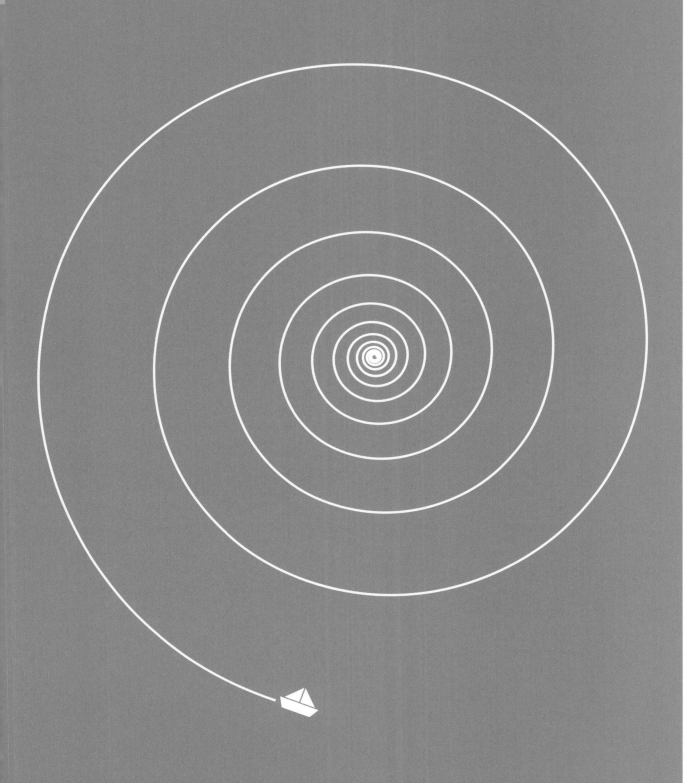

1889

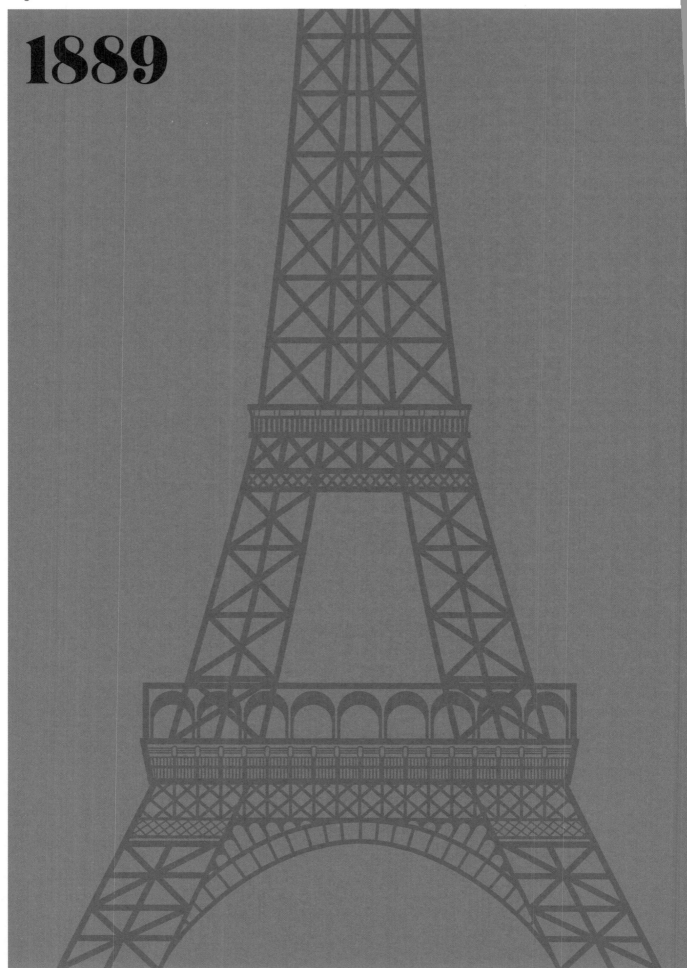

1886

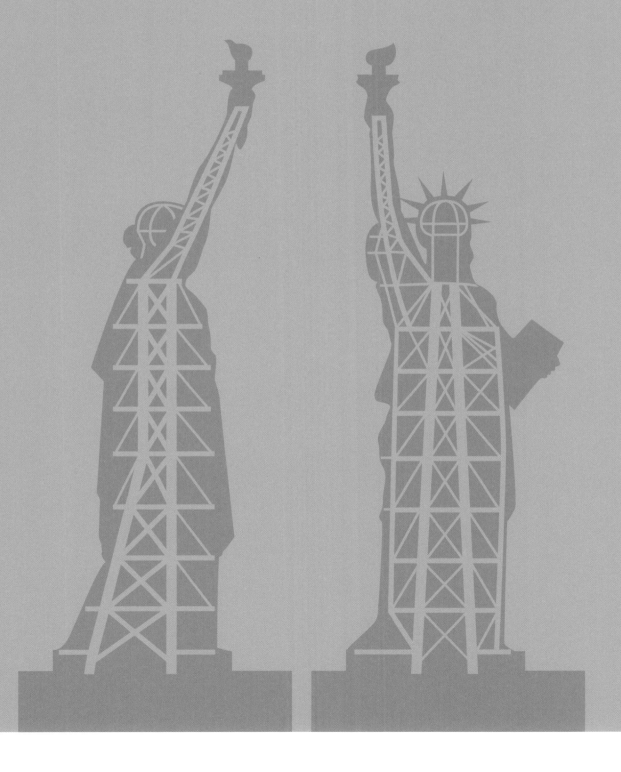

man on wire

alias philippe petit

spider-man

aka peter parker

garçons

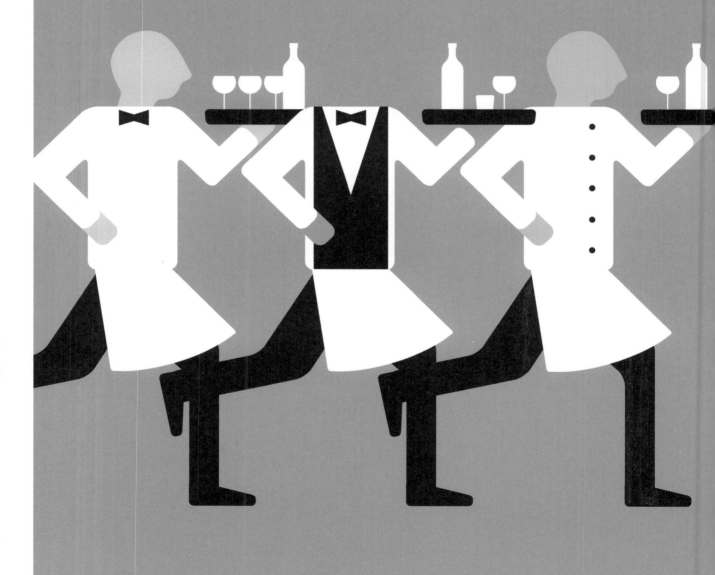

marathon

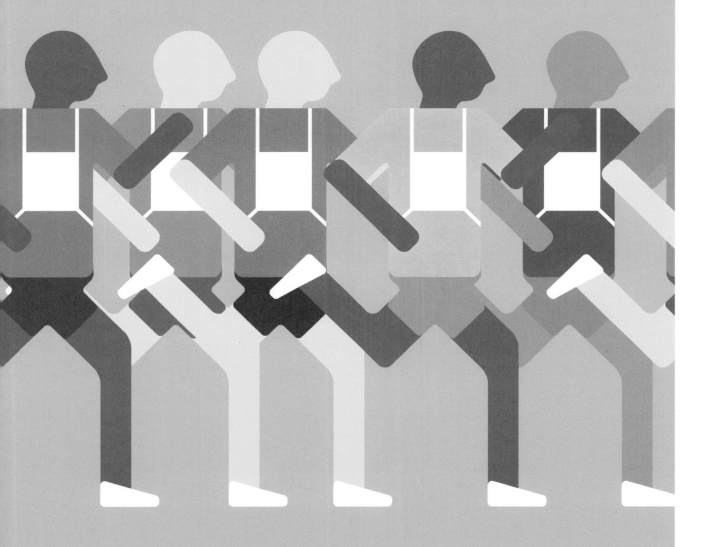

roland-garros

us open.

parc des princes

giants stadium

à montmartre

carrie

in the upper east side

taxi?

taxi!

la bouche

the globes

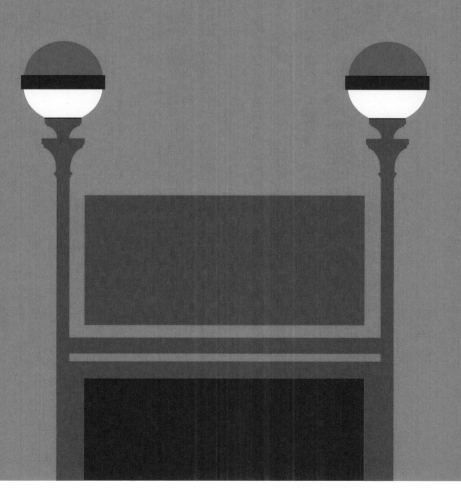

santé

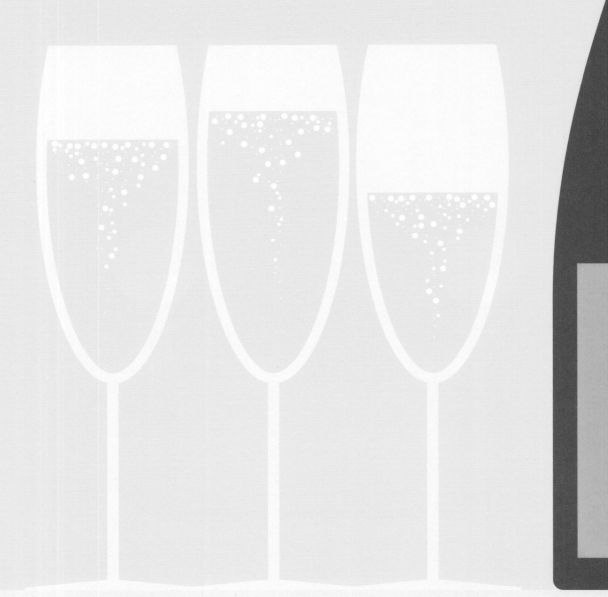

cheers

maçaron

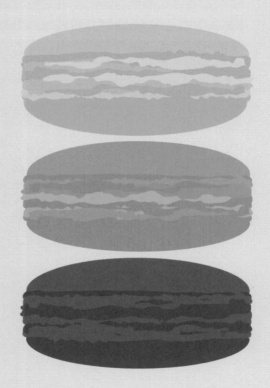

cupcake

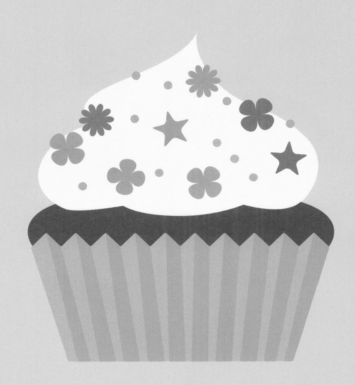

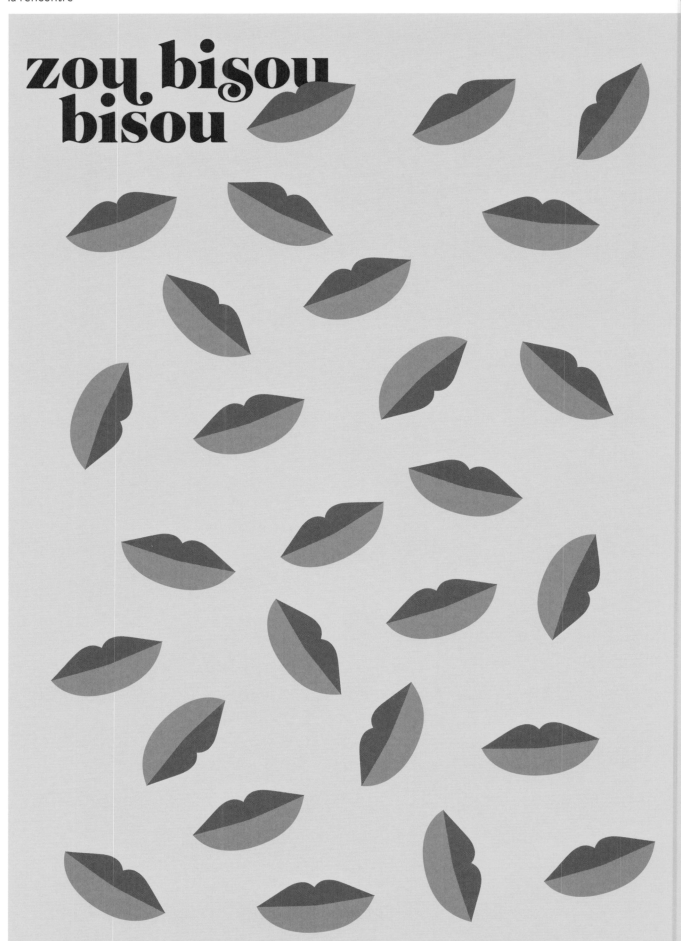

shake shake

daft punk

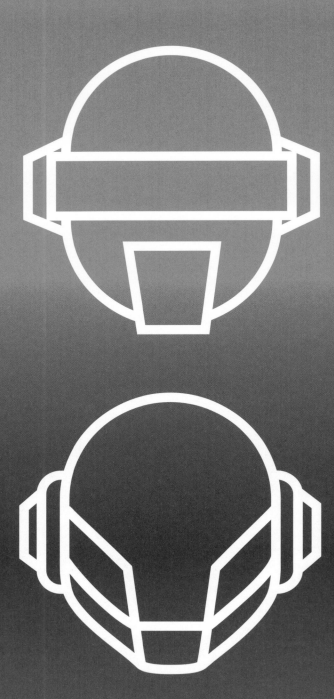

disco
funk

dimanche matin

paris s'éveille, toutes les fêtes se terminent à la boulangerie

sunday morning

the best hangover song by the velvet underground

ne me quitte pas

call me!

correspondance

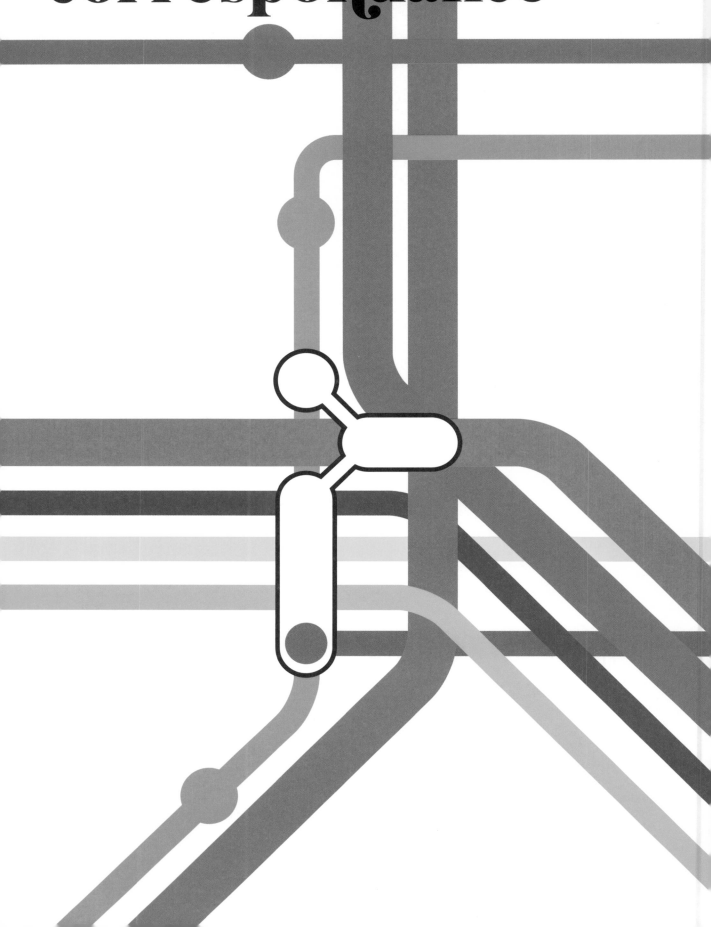

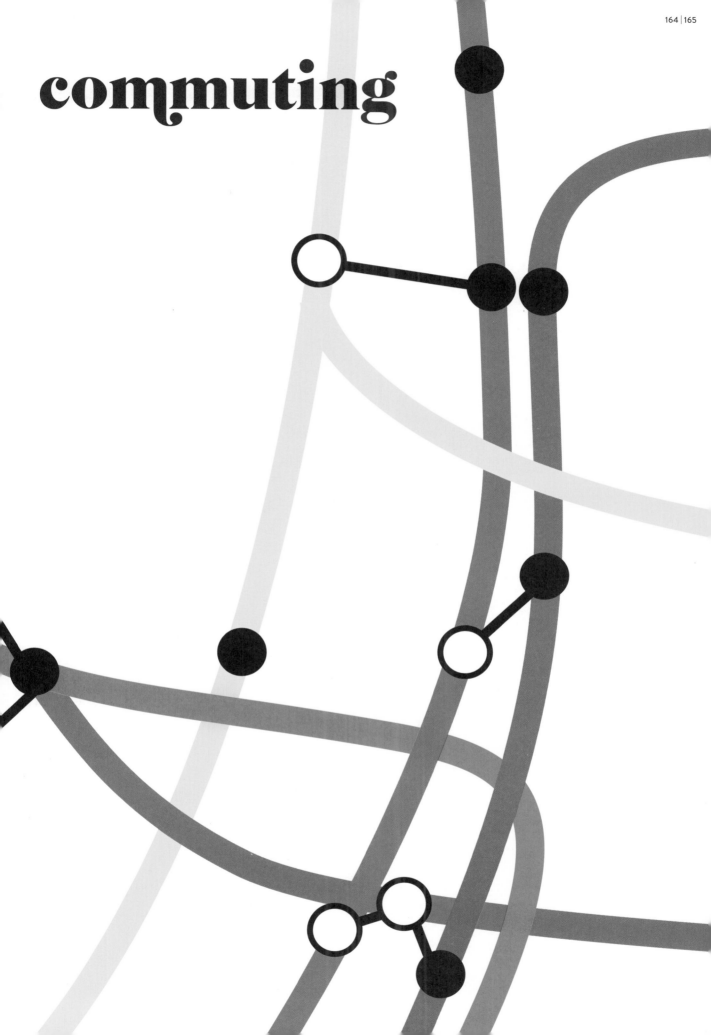

commuting

métro

subway

quotidien

format berlinois

daily
broadsheet format

expresso

assis en terrasse

americano

keep walking

pause

go

réunion

power point

deux heures

five minutes

place du marché

union
square

deauville

hamptons

14 juillet

4th of july

paris plages

coney island

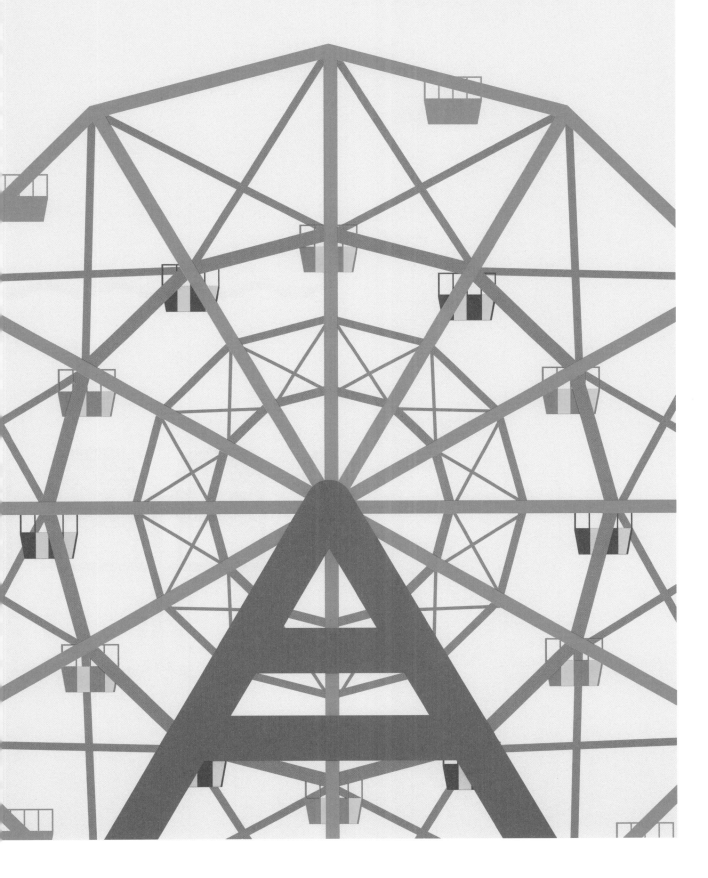

a sunday in paris

tour eiffel
café de flore
le marais
père-lachaise

un dimanche
à manhattan

gospel in harlem
brunch
shopping at abercrombie
central park

spa chic

psychic

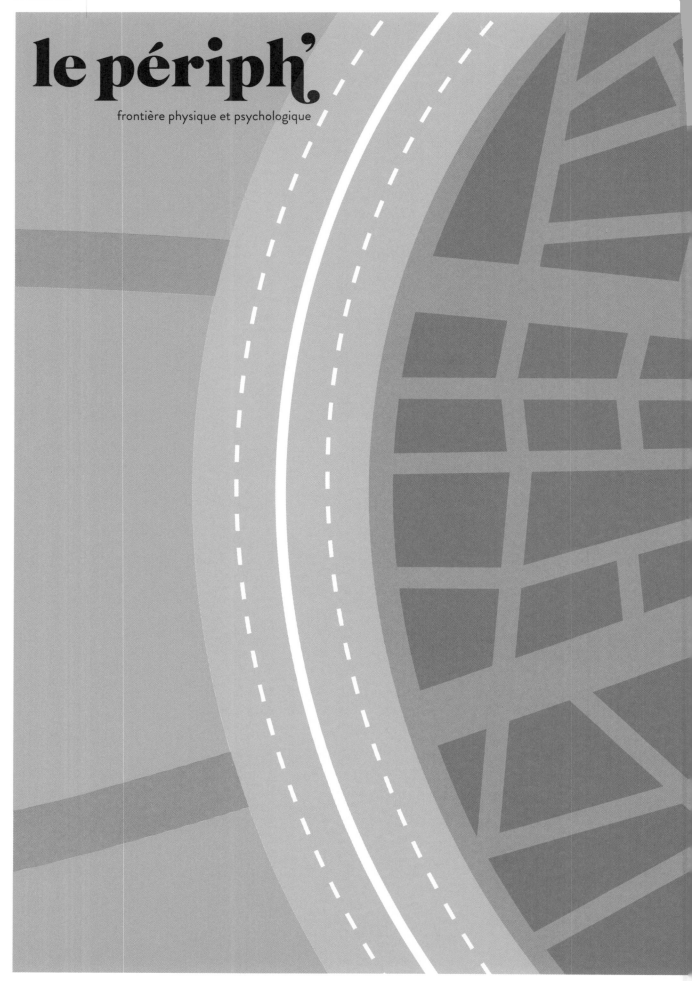

le périph'

frontière physique et psychologique

bridge&tunnel

the difference between "in and out"

giverny

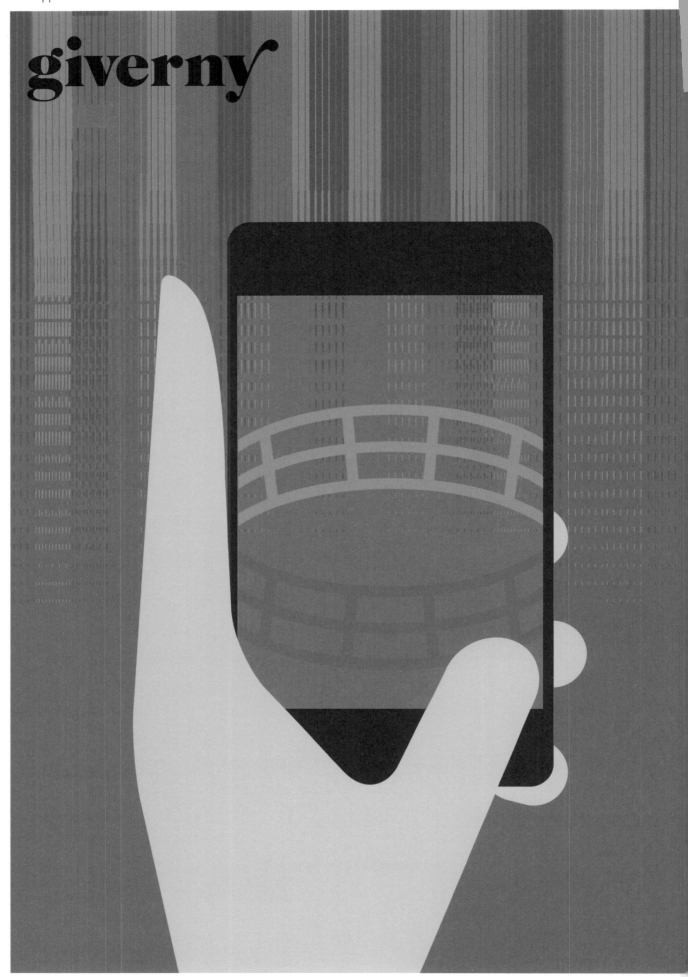

stormking

gare de lyon

la guardia

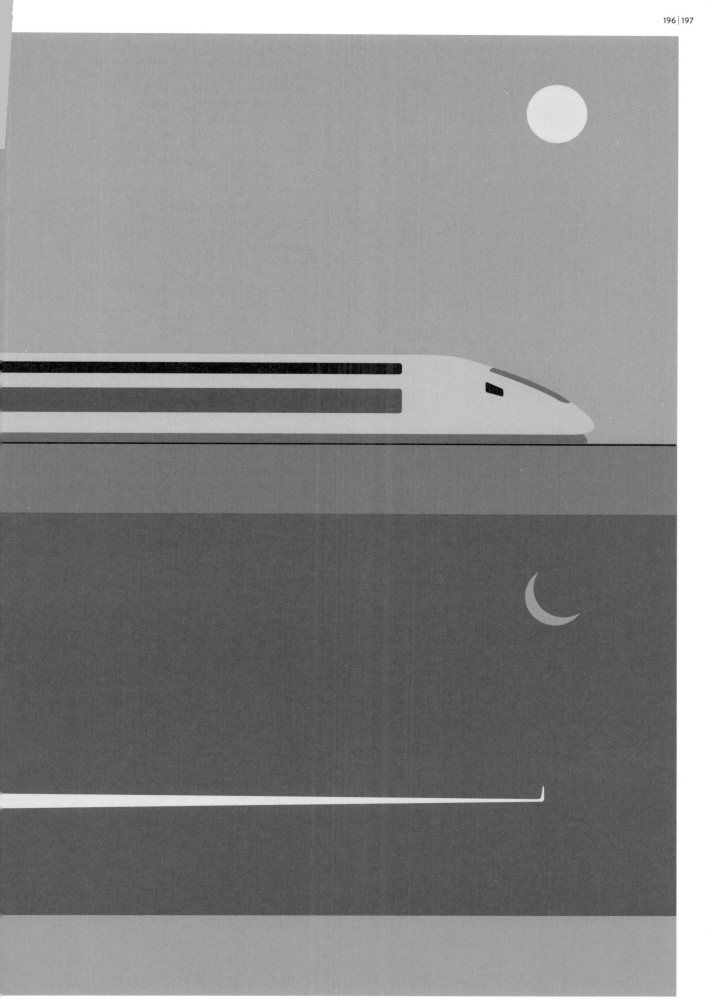

tout autour

EUROPE

PROVINCE

BANLIEUE

la seine

rive droite

PARIS INTRA MUROS

rive gauche

L'ATLANTIQUE

périphérique

GRAND PARIS

FRANCE

AFRIQUE

CANADA

CONNECTICUT

NEW JERSEY

hudson river

uptown

MAN
HAT
TAN

downtown

THE ATLANTIC

east river

BROOKLYN
QUEENS BRONX

LONG ISLAND

USA

roi-soleil

rockefeller

le petit prince

the lion king

truffaut

les 400 coups

scorsese

mean streets

depardieu

le dernier métro

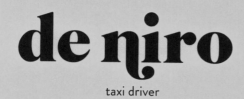

de niro

taxi driver

la sorbonne

columbia

proust

salinger

godard

nouvelle vague

les galeries

palais
royal

public relations

gainsbourg

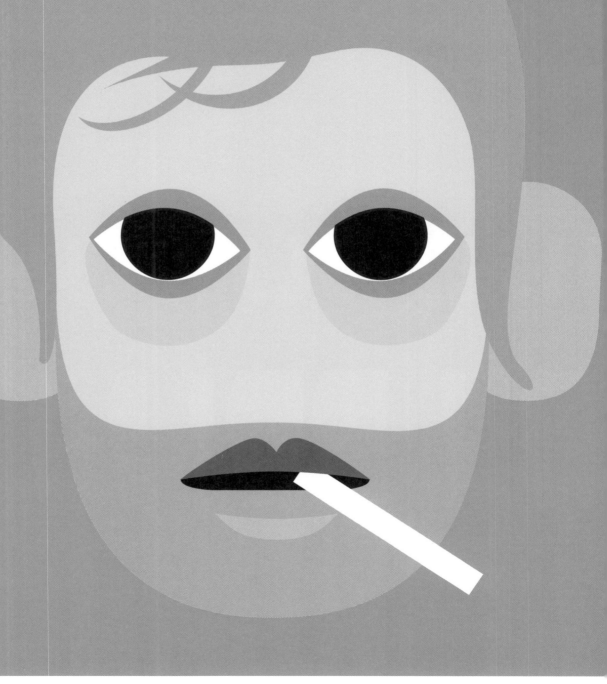

warhol

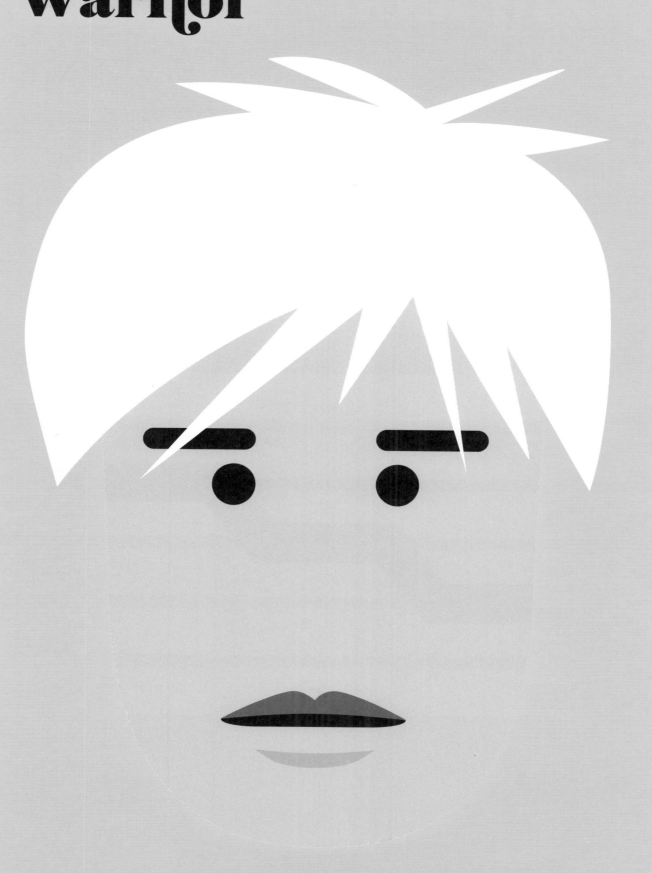

pompidou

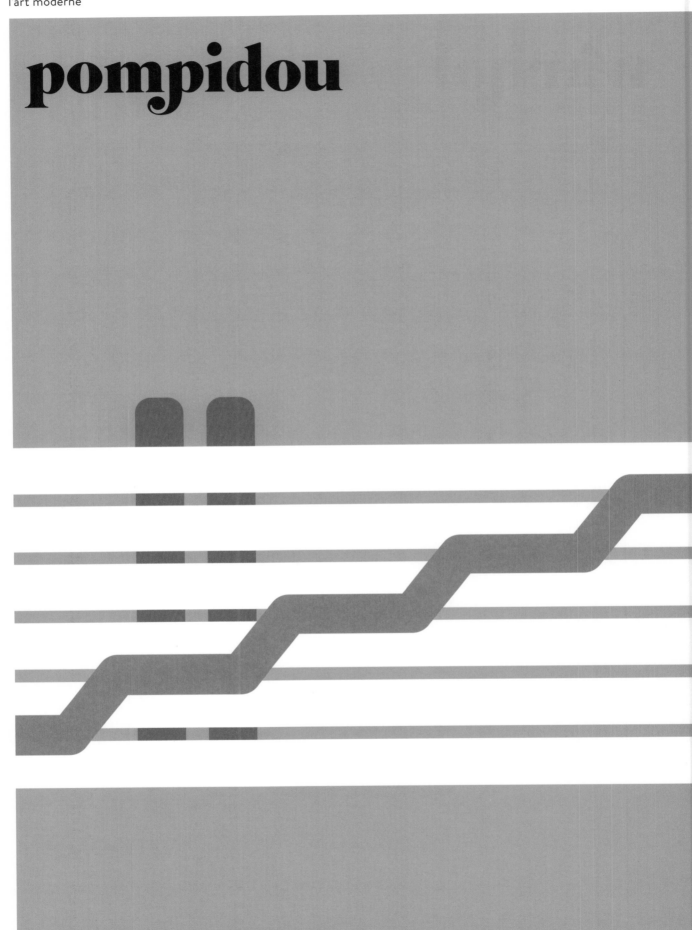

guggenheim

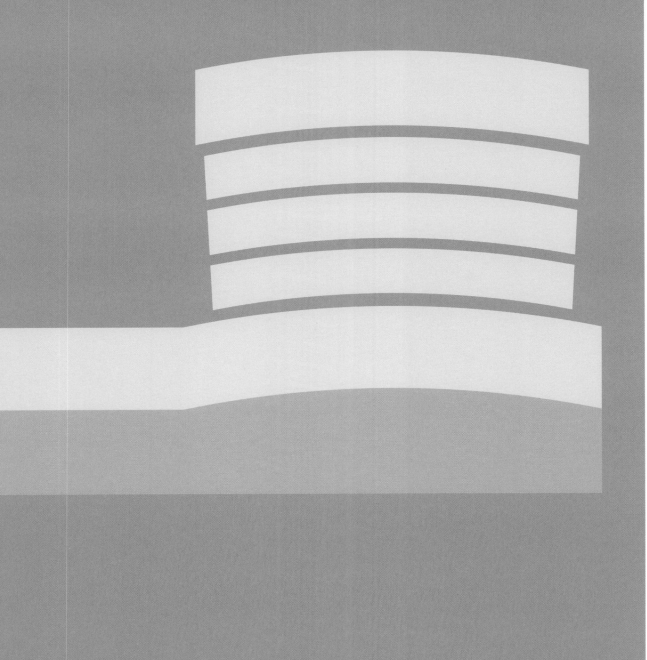

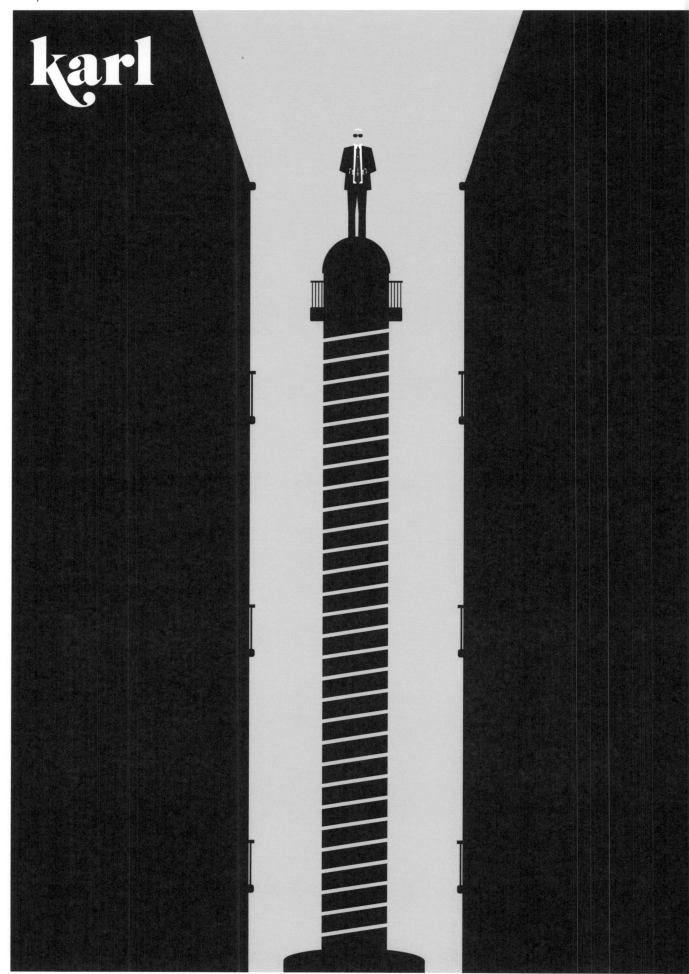

marc

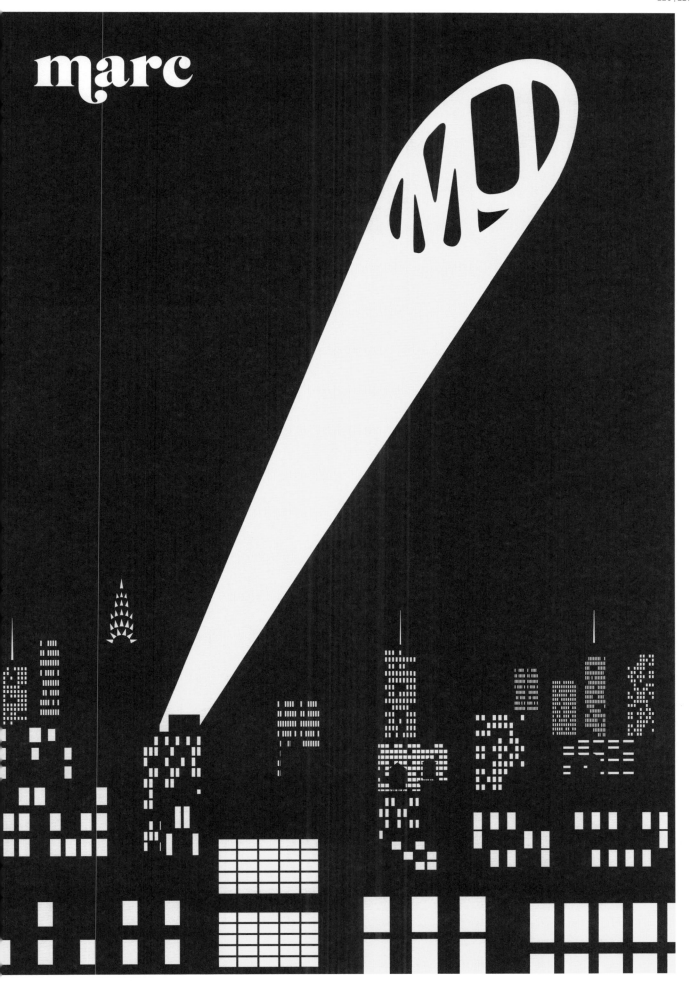

sonia

la créatrice

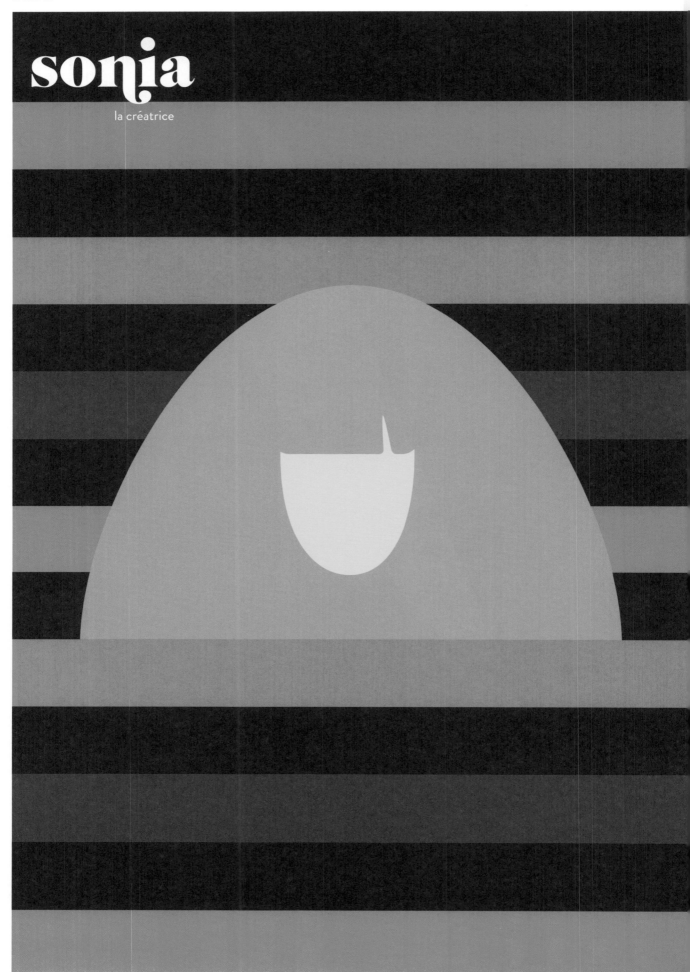

anna

the critic

prêt-à-porter

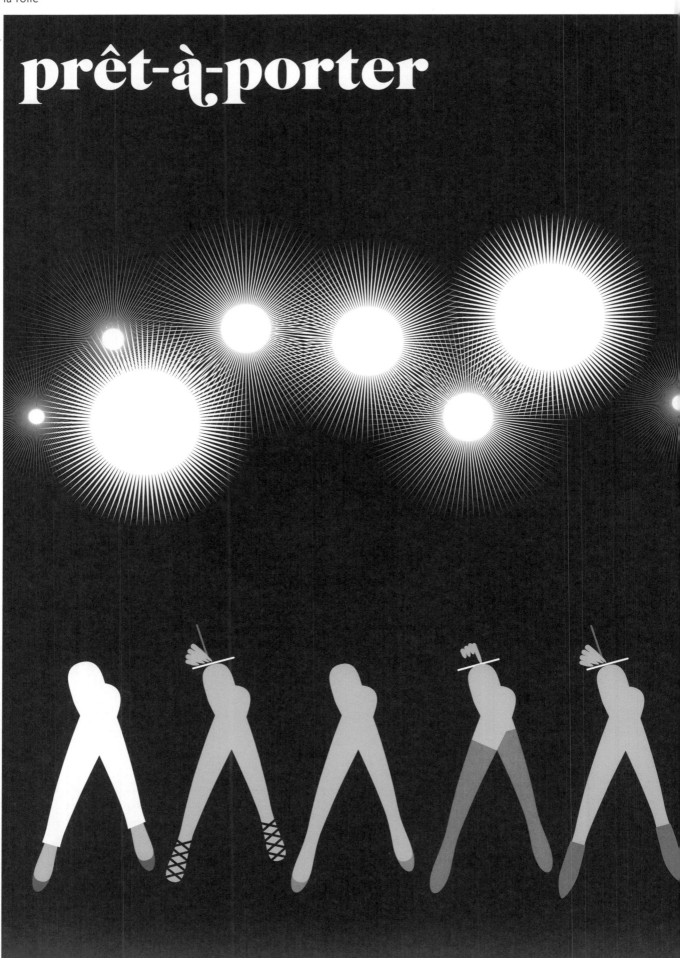

fashion week

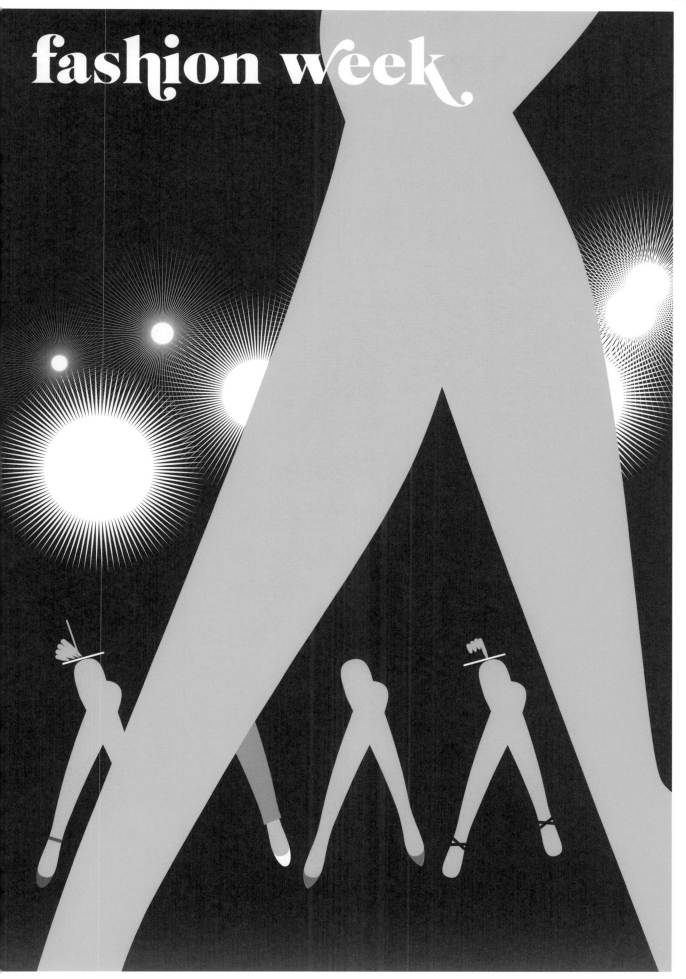

champs-élysées

fifth avenue

manif

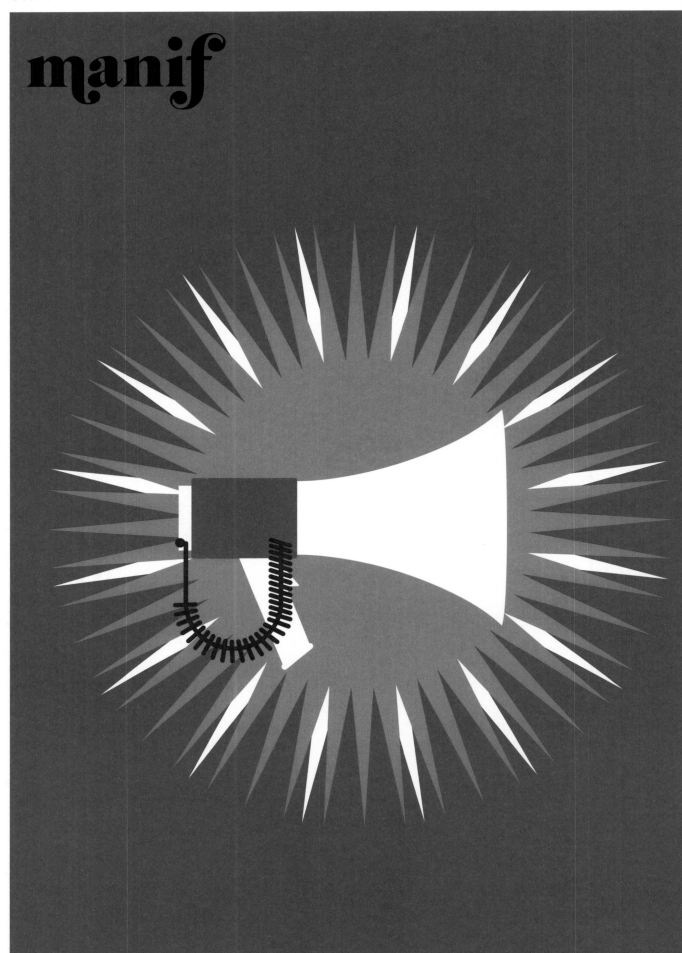

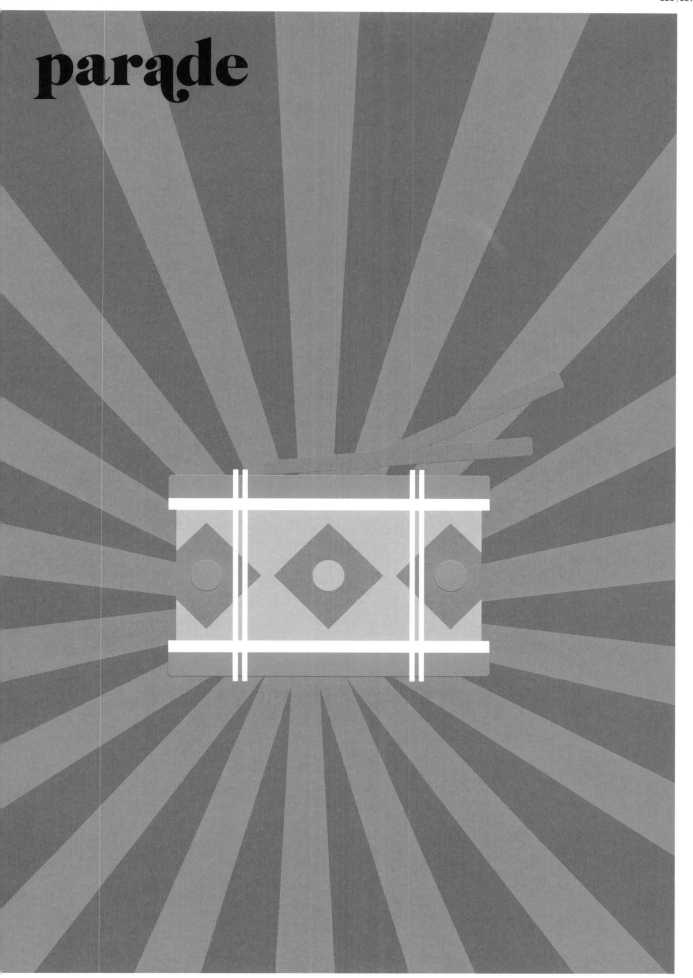

parade

tabac

nails

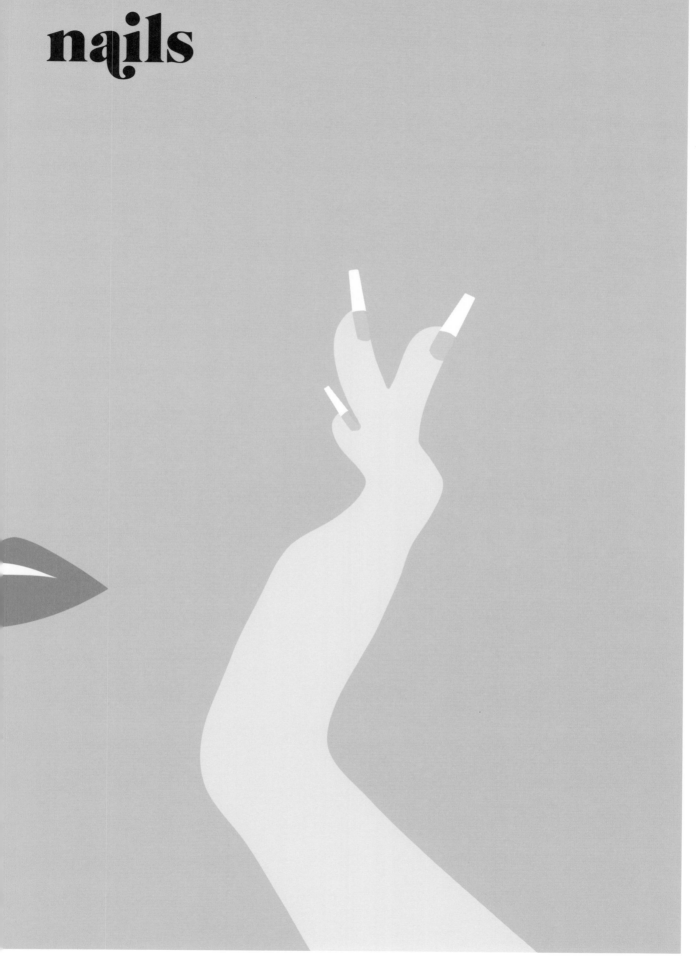

cartier

tiffany

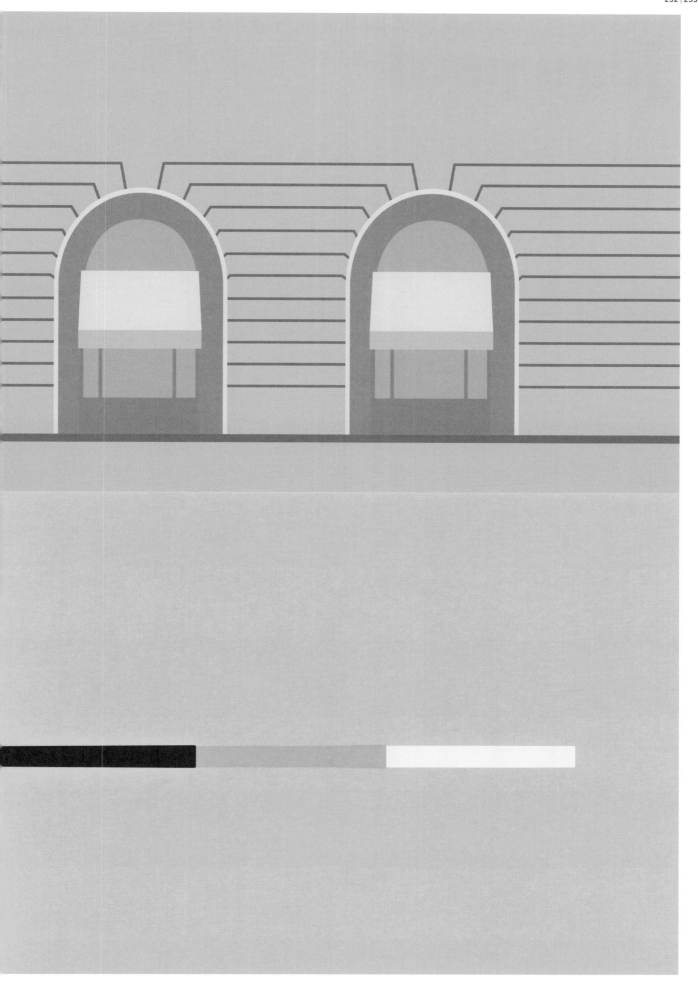

jean paul

ralph

parisienne

mad men

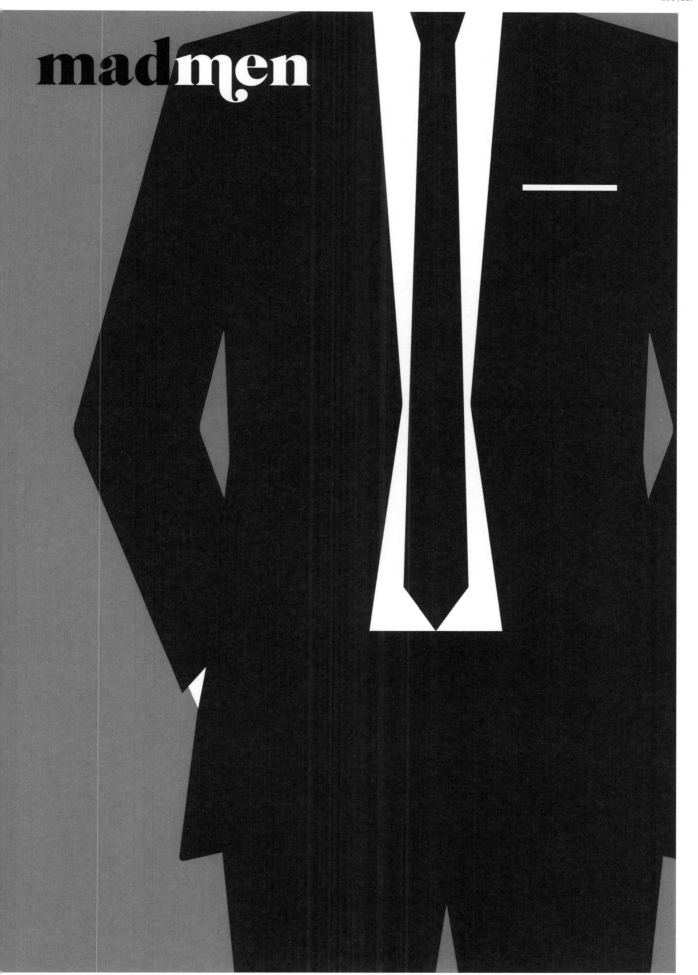

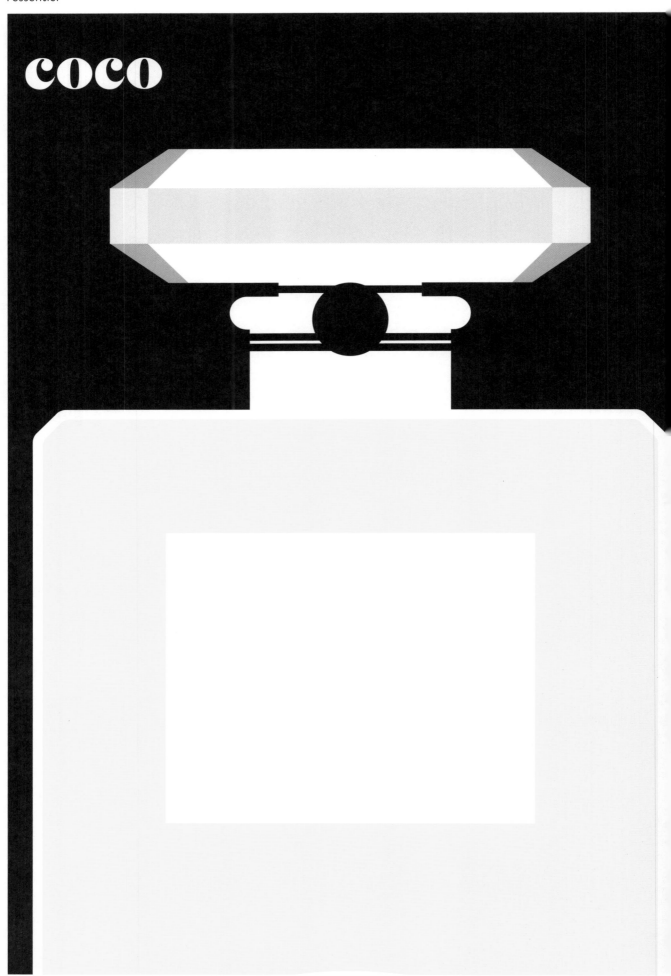

calvin

catherine

belle de jour

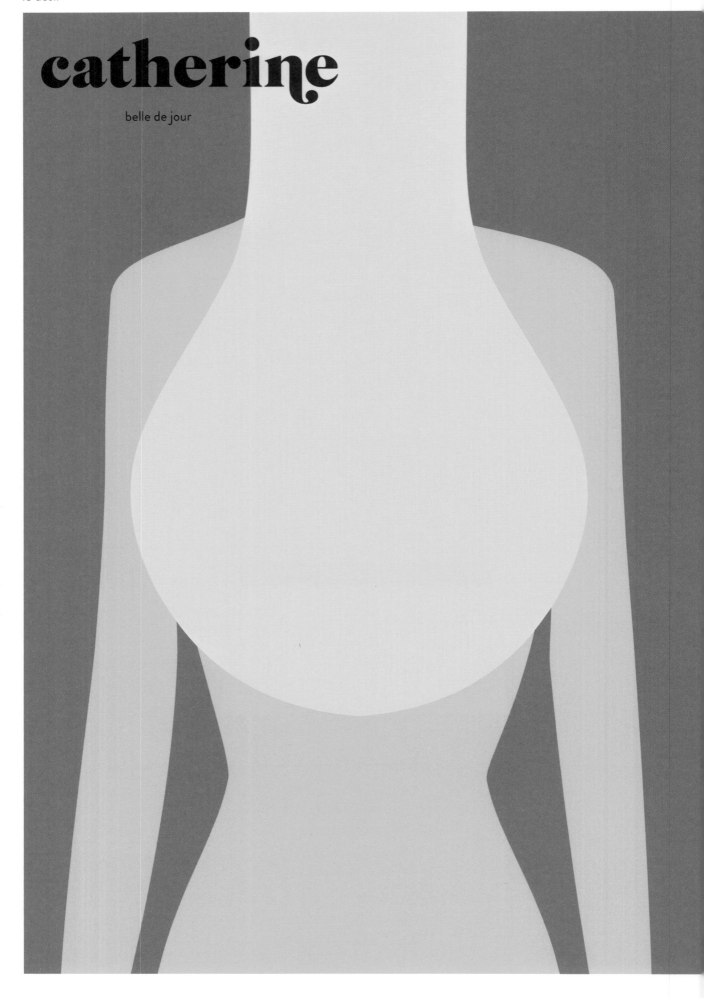

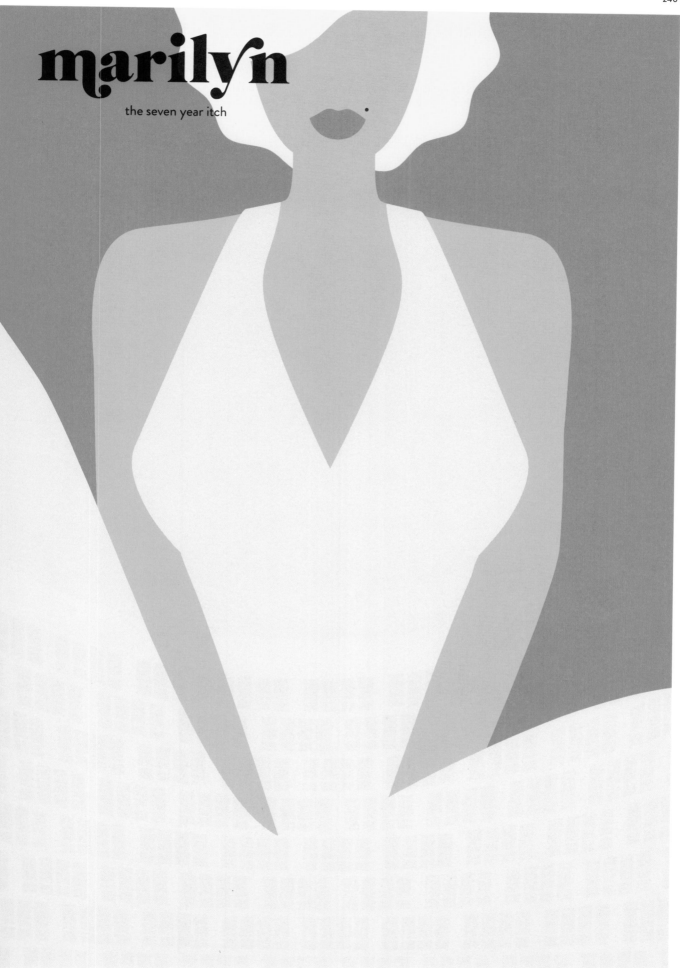

marilyn

the seven year itch

unesco

united nations

centre de la France

center of the World

inondation

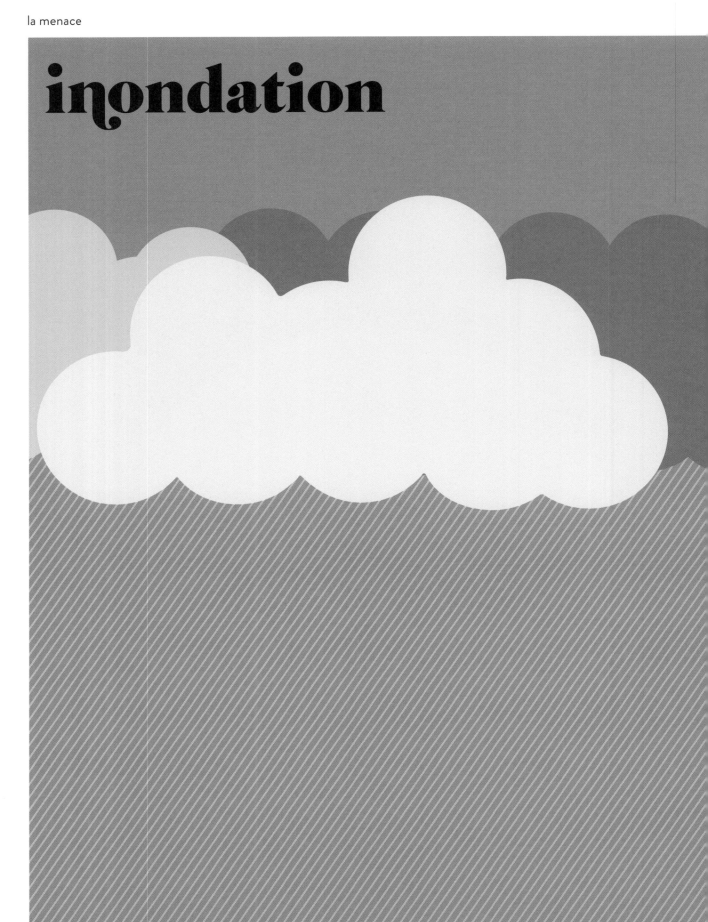

invasion

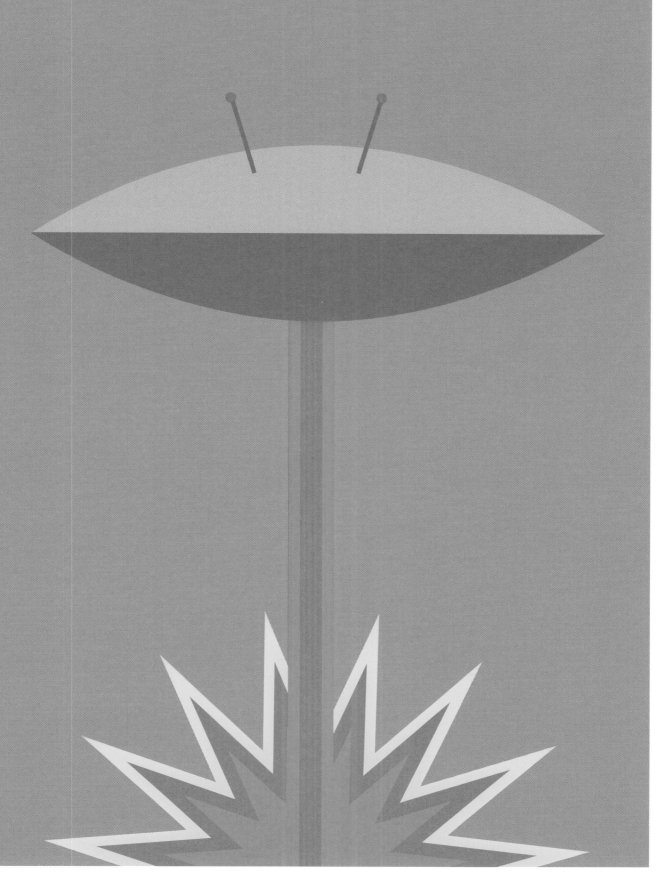

la peste

pigeon

rat volant

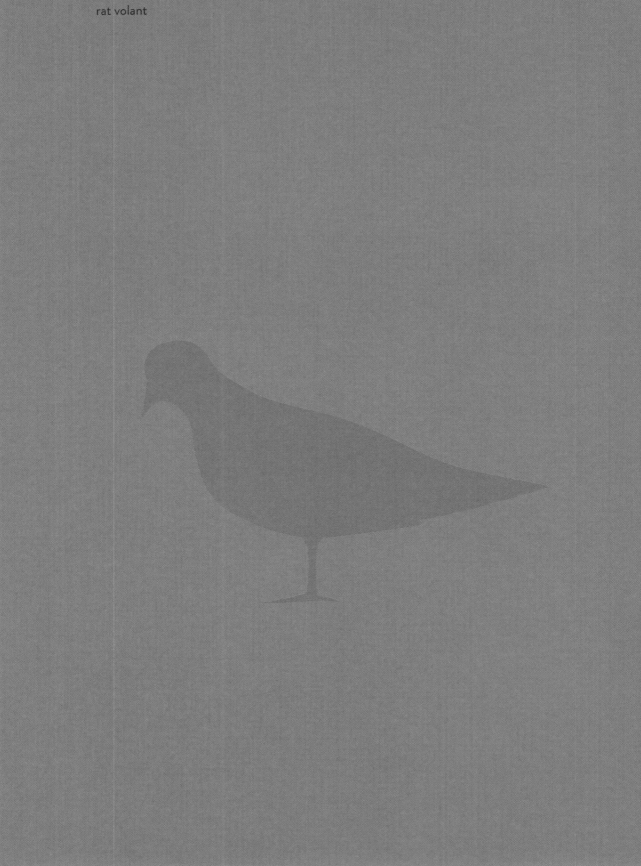

rat

wingless pigeon

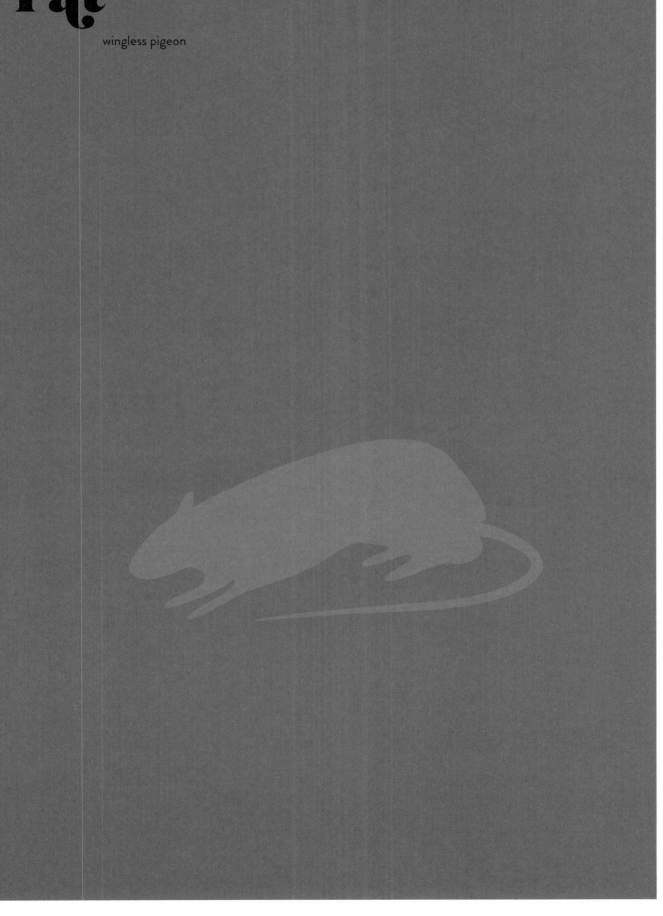

tri sélectif

déchets — papier — verre

recycling

trash — paper — glass

coulée verte

de la bastille au bois de vincennes

high line

from the meatpacking to midtown

bobo

dans l'est parisien

hipster

on williamsburg bridge

pour tous

le vélib', le prêt-à-rouler

for two

you'll get there eventually

la voiture

XS

xxl

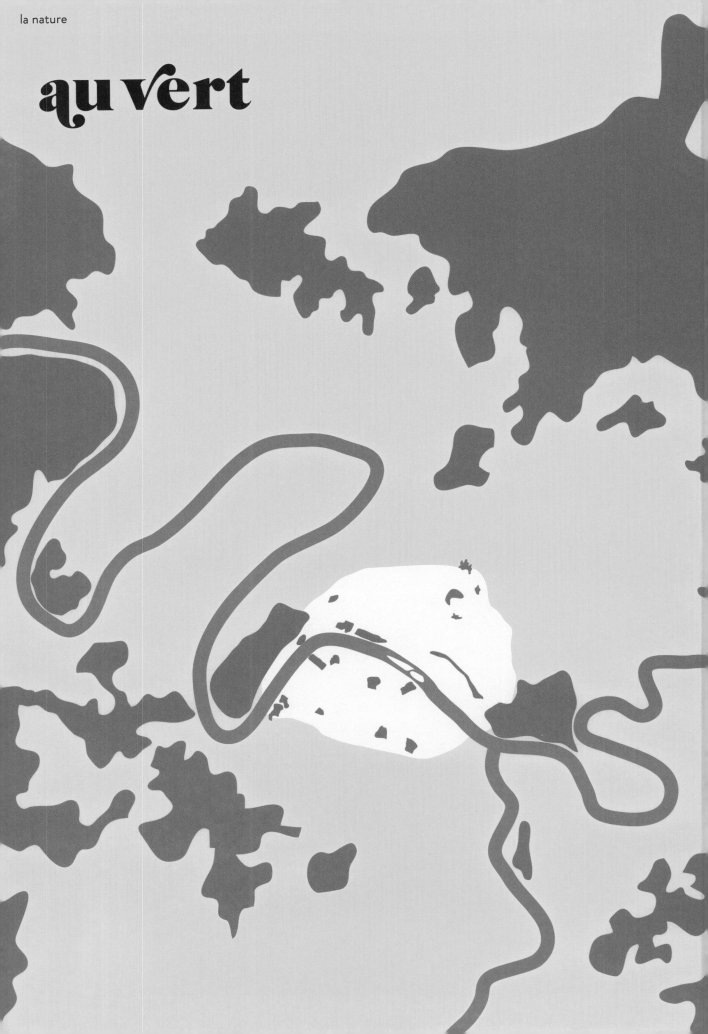

la nature

au vert

go green

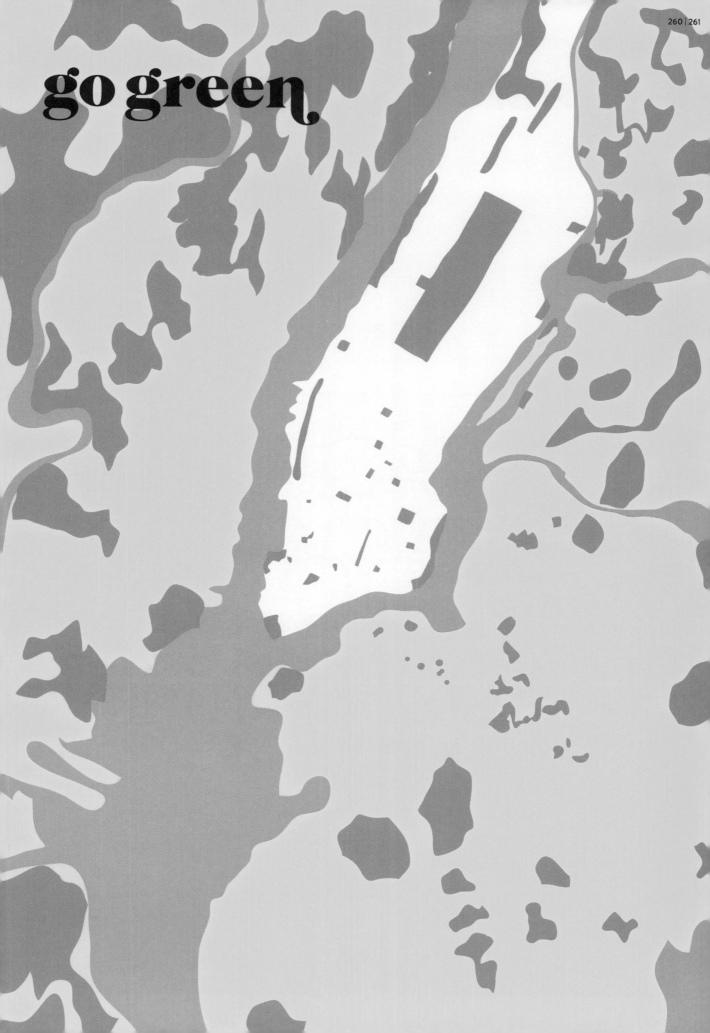

au soleil

speakeasy

bordeaux

cosmo

conversation

dialogue

brasserie

diner

baguette

+ beurre demi-sel

bagel

+ cream cheese

salé

sucré

café

serré

expresso

allongé

cappuccino

viennois

noisette

café crème

américain

irish coffee

coffeehouse

americano

black

long black

latte

breve

macchiato

double espresso

mocha

frappuccino

pourboire

service compris

tip

just double the tax

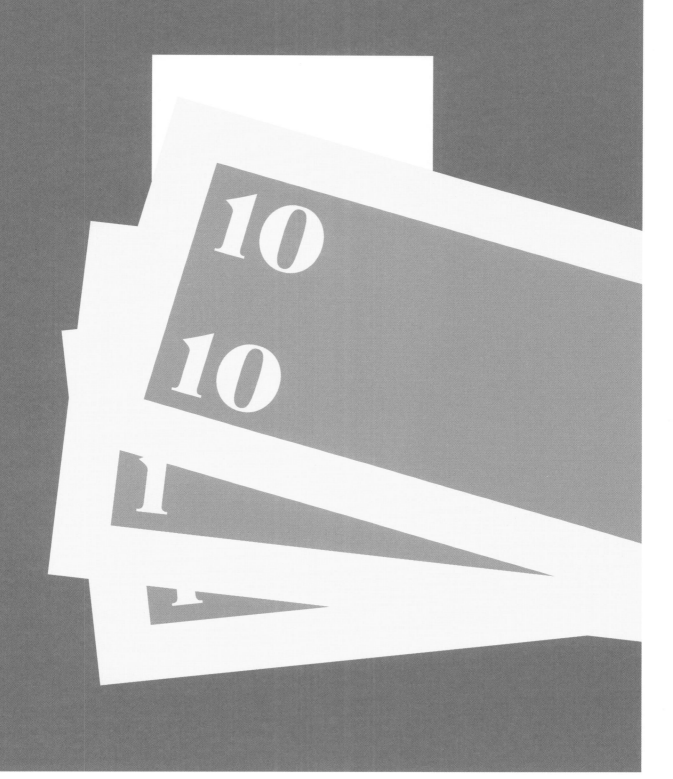

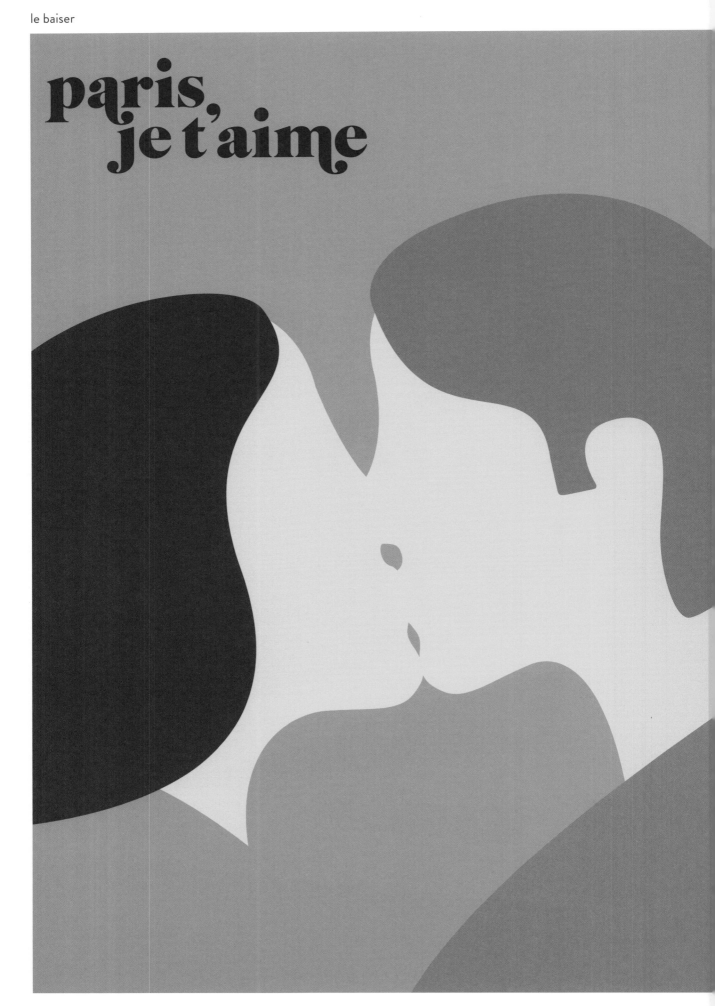

paris,
je t'aime

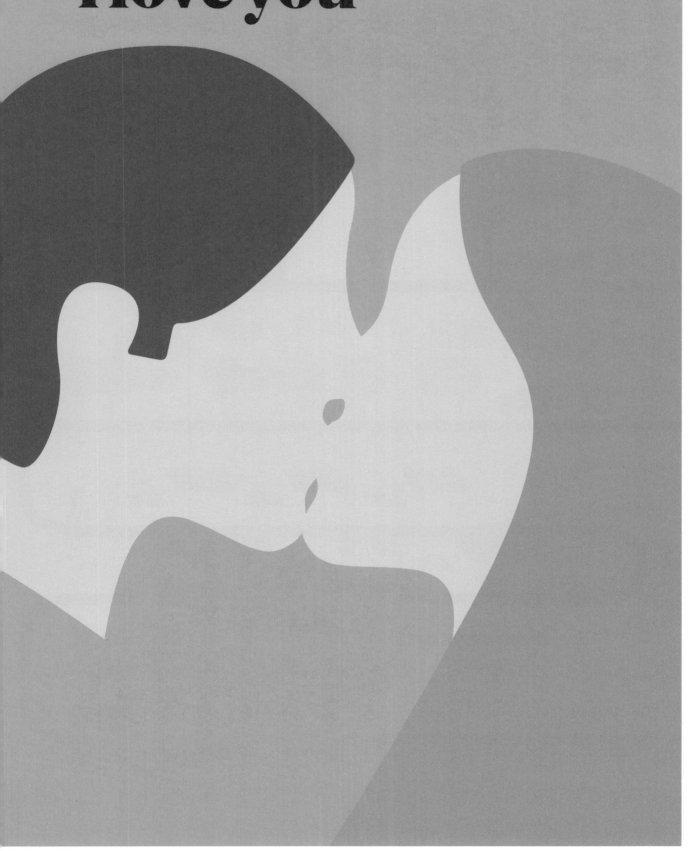

après paname

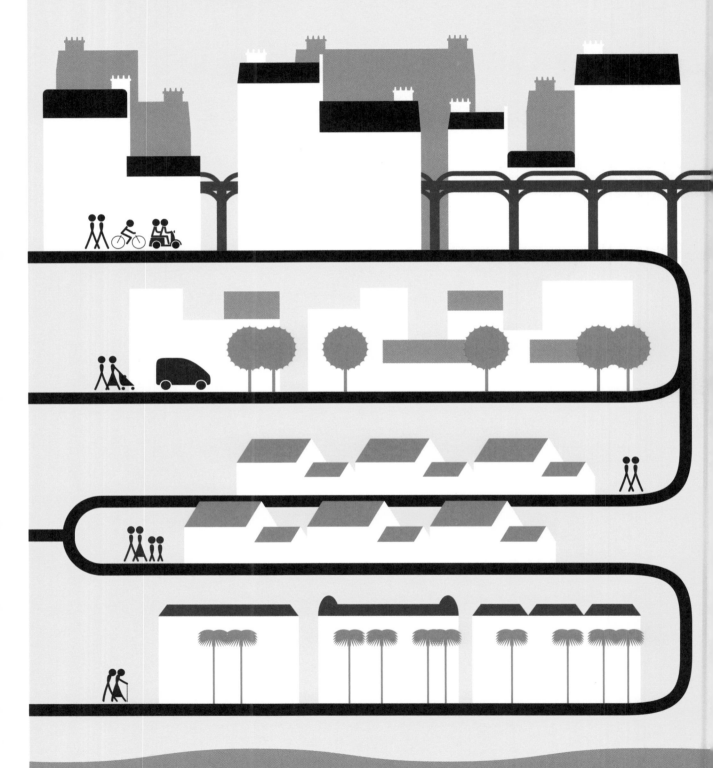

after gotham

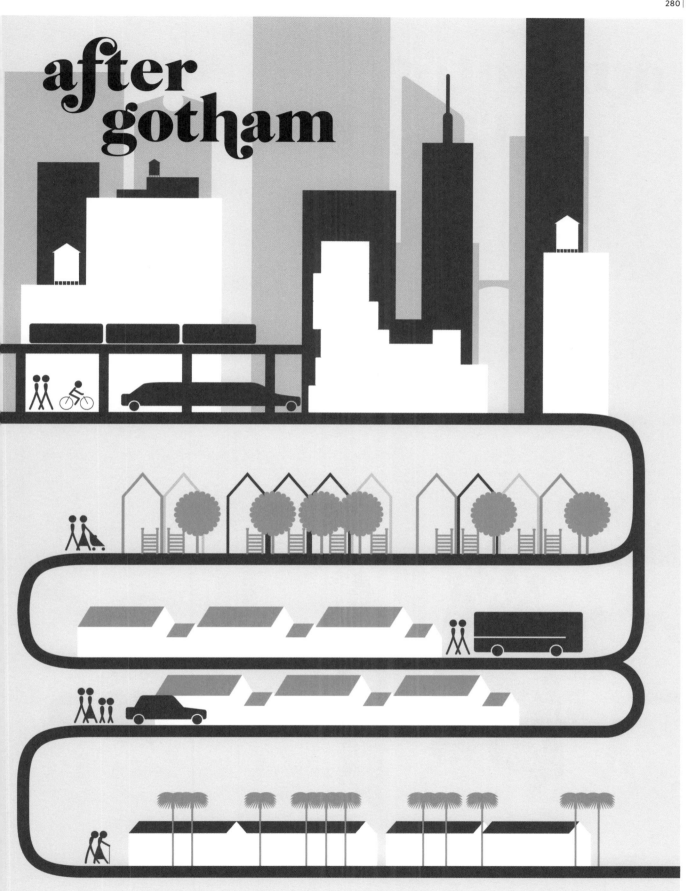

les voisins

à bientôt
paris

londres
rome
berlin
barcelone
le caire
istanbul

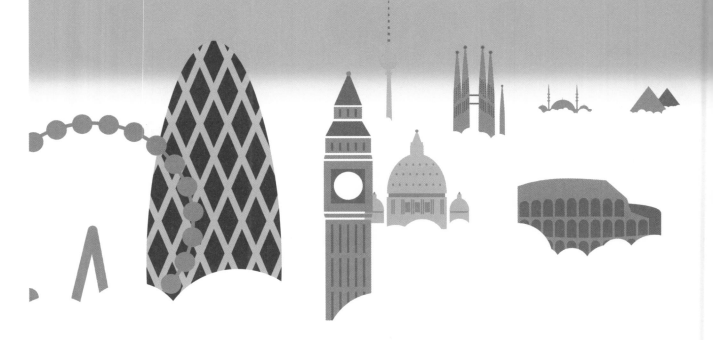

so long
new york

san francisco
st. louis
cape canaveral
chicago
rio
mexico city

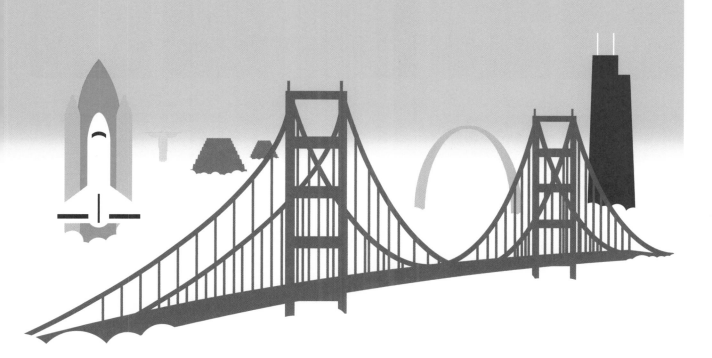

Paris versus New York

bon voyage

MERCI | THANKS

For their support, their suggestions, their presence at different stages of the design of this book, many thanks to the dream team at Penguin Books, Laura Tisdel, Sonya Cheuse, Stephen Morrison, Elda Rotor, Patrick Nolan, Rebecca Hunt and Langan Kingsley. Kudos to my great agents, Caroline Zimmerman and Brettne Bloom.

I'd like to say merci to my tremendous editor Emmanuelle Heurtebize, plus the enthusiast ladies Marie-Laure Pascaud, Bénédicte Adrien, Van Hy Lau, Bénédicte Gimenez and the 10/18-Univers Poche team.

My experience would not have been possible without my beloved second family, Sandra Stark, Jim Mersfelder, Eve Mersfelder, or without the valuable advice of Meline Toumani, Marie Cortadellas, Barbara Fourneau and all my friends in the Big Apple.

This adventure is *way* beyond expectations thanks to Thiery Teboul Fontana, Sonia Kalaydjian, Camille de Villartay, Marie-Amélie Degail, Anouche Der Sarkissian, Aurélie Portier, Bernard Baissait, Sarah and the colette gang, all the members of my beloved family — present or missing. Last but not least, thanks to my sweet brother Arnaud, and my amazing parents, Armand & Viviane, for giving me the chance to start creating this match in my head until I was able to share it with the world.

vahram muratyan